Polaroid
How to take instant photos

Polaroid
How to take instant photos

MITCHELL BEAZLEY

Contents

Introduction

Before Edwin H Land (1909–91) invented the *Polaroid* camera, taking pictures involved a lot of waiting around. You loaded up your camera with film, started snapping, but then handed over the finished film to be developed in a processing laboratory, or processed the film yourself. It as days before you could see how your photos had turned out.

Land was a scientist whose mission in life was to look at the impossible and try to work out how to make it possible. He was inspired by his three-year-old daughter, who wanted to know why she couldn't see her photos straight away. So he developed the 'Land' camera, an easy-to-use device that handily combined photography, developing chemicals and a darkroom in one neatly designed package. Unsure how people would take to this entirely new way of taking pictures, his company tested the waters with a small trial – they made 60 cameras, 57 of which went on sale in a Boston department store. They sold out within a day.

The appeal was instant, the colours amazing. Artists loved it. Ansel Adams used it to take atmospheric landscapes. It enabled Walker Evans, the Great Depression–era documentarian photographer, to keep on working when his hands were no longer able to lift heavy cameras. Chuck Close used *Polaroid* pictures when creating his giant portraits. David Hockney stopped painting for a while and concentrated on making *Polaroid* picture collages. Pop artist extraordinaire Andy Warhol, who loved the intimacy and immediacy of the medium, snapped the people hanging out at his New York studio with a huge cache of film and his Polaroid SX-70 camera. He also used his *Polaroid* snaps as the basis for his silkscreen portraits, including those of Elizabeth Taylor and Liza Minnelli.

It wasn't just artists but also street photographers, pop stars, filmmakers and astronauts who embraced Land's cameras – the Skylab 3 and 4 crews even used a *Polaroid* camera to take pictures while orbiting the Earth. And pretty much everybody else fell for it as well: the famous click and whirr was

heard at family get-togethers, parties and days out, anywhere that a magical memory could be captured and delivered instantly. Because each picture was unique, it was special, a treasured one-off.

But those days aren't over: you can share a slice of that retro nostalgia by taking your own *Polaroid* photographs. Unlike digital, where it is all about snapping and deleting until you come up with a picture you like, taking perfect *Polaroid* pictures means slowing down and savouring your surroundings in the search for the loveliest light, the most striking of images.

It is a whole new way of looking at the world, right in the palm of your hand.

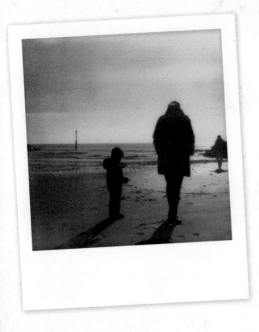

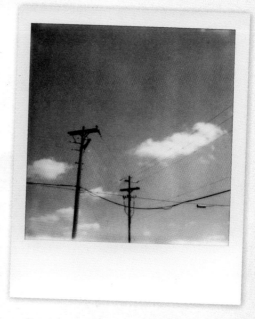

The basics

Before heading out on your great visual adventure you're going to need to load up with a camera and some film. And, once they're in hand, it's a good idea to think about a few simple things that will help you take a good picture. This chapter covers basic info on how *Polaroid* cameras work, and the types of films they take. It also gives you an overview of some simple tips and techniques, from lighting and composition to camera angles, to inspire confidence before you click.

Choosing your camera

Before you go out into the big wide world with your *Polaroid* camera, it's a good idea to get acquainted with the quirks of your device.

If you're buying it brand new, then it's all very straightforward. Everything you need to know about getting started will be on the box that the camera came in. But if you're going down the vintage route, there are a few things to bear in mind.

There are lots of old cameras around and, though they may look beautiful, some classic models have lived a long life already and won't necessarily be capable of taking pictures – and it may prove difficult to find the film for some of them (see page 14).

If you're buying a *Polaroid* camera online, peruse the listing carefully and make sure that the camera has been tested with film and works smoothly. If you're looking to pick one up in a charity shop, thrift store or garage sale for not much money, well, you might be lucky and discover a gem, but have a good look at the camera before you decide to buy it.

Check that the lens isn't scratched; if it is, then any picture that you take will print with those same scratches in place. It doesn't matter so much if the viewfinder is a little damaged; it won't affect your pictures, though it will be annoying to look through. Make sure that the rollers still roll – these push your picture out of the body of the camera, and any issues with these can prove problematic. Sometimes the rollers are simply grubby; if left that way, they will smear your

It isn't hard to start taking great photos with your instant camera, but it's worth spending a little time to make sure you have the model that's just right for you.

pictures with dirt, but they're fairly easy to clean – just use a damp or dry cloth to get rid of any residue. (Make sure that the rollers are completely dry before putting in the film.)

A real problem to look out for is a corroded battery chamber. You may find that old-fashioned batteries have been left in the chamber for a long period of time; unlike modern batteries, if the old-style ones leak, it pretty much welds them in place, and no clean-up job is going to be able to salvage the camera as a working model.

On really old *Polaroid* cameras there might be holes in the bellows – these are the pleated fan bits that hold the lens, and any holes or punctures are going to let in light where you don't want it to go. You can patch them up, but be aware that this involves quite a bit of work and so is possibly not the best option if you're just starting out on your *Polaroid* adventure.

If your potential purchase has any of these flaws, it may not produce perfect photographs – though it's worth remembering that the beauty

of some of these older models is in the unexpected results that less-than-perfect examples can produce. Even if your camera is scratched or has the odd puncture, it may be able to work with the chemicals in the film to create some magic – an abstract piece of art that is just what you're looking for. But if you're after a plain-and-simple point-and-click camera, then be aware that any of the issues outlined above will mean that you won't get the results that you're hoping for.

If your camera looks as though it's in working order, it's worth having a look at its features before you think about getting some film. Again, if your *Polaroid* camera is a new model, then all the information you'll need is on the packaging; if it's an older model, the Internet is a good source of knowledge; there are hundreds of models of classic *Polaroid* camera, and hundreds of *Polaroid* aficionados out there in the online community.

Some things that it's useful to look out for are a film speed dial, a light and dark conditions control, a focusing wheel and an exposure dial. If your

model has any of these, then it's a good idea to read up on what they do before getting started.

What all *Polaroid* cameras have in common are a lens, a shutter button, a viewfinder and a slot where the picture will eject. Get used to holding the camera in your hand. Be aware of where your fingers are; as with any camera you don't want fingers or thumbs on the lens as they'll make an unwanted appearance in your pictures, and you don't want them over the ejection slot either, as this will get in the way of your emerging picture. Look through the viewfinder to see how the world looks; depending on the model of camera you're holding, you might have to move the focusing wheel back and forward to change the world from blurry to crisp and clear.

The next thing you'll need is film.

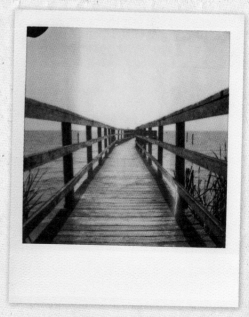

Film star

Although the original film is no longer being manufactured, there are still plenty of ways of getting your hands on everything that you'll need to start shooting pictures.

It's still possible to discover batches of expired stock, particularly on the Internet. Out-of-date film may still work (and the chances are better if it has been stored in a fridge or a chilly garage, but not a freezer or a sweltering attic), but it's going to behave in entirely unpredictable ways – the little pool of developing chemicals will be past its best, and that affects the colour balance and the way the picture develops, so the result could be unexpectedly patchy or simply not come out at all. That said, the pictures could also be unexpectedly pretty, and some *Polaroid* fans love to see the unique results that out-of-date film can produce. But it can also be expensive, and so you may want to look at more reliable sources of film.

There are a number of companies that still make instant film that will work in various models of *Polaroid* camera. Each film will behave slightly differently, and different cameras take different types of film. Your best bet is to read all the information on the film's box, and check out online forums to get the lowdown on each film and its pros and cons, and which film works with your particular model of camera.

There are two kinds of instant film: 'integral' and 'pack' film. Integral film is very straightforward – you load it into the camera and it does everything for you. To open the film door, press down on the little tab. Next, carefully take the film out of the package and, with the small paper tab facing outwards, slide your film cartridge into the compartment, pushing it until the narrow plastic strip across the top of your film snaps open. When you've got it in place, close the film door. At this point, you may need to press the shutter button in order to eject the dark slide that's been protecting the film. Once you've disposed of this, you're ready to take your first picture.

Different film will give your photographs a slightly different look and feel.

There are usually between eight and ten exposures on each film, and to take each picture all you have to do is check the shot in the viewfinder, press the shutter button and wait for the camera to spit out the picture.

Now you need to shield your photo from the light. Unlike original *Polaroid* film, modern film has to be kept in the dark for a short while after exposure, for the chemical magic to work properly. To stop the light interfering with the development process, you can pop the print into a cardboard box or an envelope, your bag or a pocket, or lay it face down on a surface. You need to leave it in the dark for about half an hour. The film works best in temperate conditions, so if you're shooting on a chilly day you can use body heat to warm up your freshly ejected image by keeping it in an inside pocket. Once you've taken all your pictures, press the film door tab to open it and pull on the tab at the front of the film cartridge – it will slide out.

Pack film, or 'peel-apart', film is a little more complicated, so it's worth reading the procedure given below carefully to help you get the very best results.

Pack film comes in single- or double-pack boxes and will be wrapped in plastic – treat the packages gently, holding them by the sides, as rough handling can result in damage to the developing chemicals. Before you open the packaging, bear in mind that it's a good idea to load your camera away from direct sunlight. Carefully take off the foil and slide the film out, still holding it by the sides. You'll see that there are white paper tabs attached to the film pack. Now you're ready to load it into your camera.

On the base of your *Polaroid* camera there's a switch. Slide it back and it will open the film door. Slide the pack in, so that the window side is facing downwards and the tabs are facing out. Make sure that it's firmly in place, and check that the white tabs are nice and flat. Close the door firmly. There should be a large black tab poking out of the small opening – this is the dark slide. It was protecting the film from exposure to the light, but it has done its job now, so pull it straight out of the camera. You might have to put a little effort in, but don't worry too much: the thing to concentrate on is pulling it straight. The first white tab should now be sticking out of the camera, which means that you're ready to take your first picture.

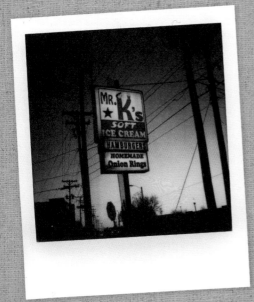

Once you've snapped your picture, you'll need to remove the film and peel it apart in order to kick-start the developing process. This needs a steady hand, a bit of concentration and some practice.

Grab hold of the white tab that's sticking out of the camera and pull it out, straight and steady. As you pull, a little door will open, and a larger black tab will appear. This is the film. Pull the larger tab in the middle – slowly, steadily and without stopping, and always keeping the tab straight. You'll feel a bit of resistance but keep pulling. This action is what makes the little pod of chemicals within the film pop, and as you pull you're spreading them over the print – they need to be evenly coated for the best results, which is why a slow, steady hand is essential here.

Try to keep an eye out for everyday images and scenarios that might make for an interesting photo.

Now you need to let the picture develop. (The timings for this should be on the box the film came in, and can be anywhere from 15 seconds to four minutes and counting; don't cut that time short.) During this time, let the film hang from the tab without moving or lay it down flat – don't touch or bend the main bit of the picture or you will damage your print.

When the time is up, carefully peel the white sheet from the backing paper, peeling from the tab end to avoid getting your fingers covered in chemicals. The print will still be wet, so make sure that you don't get fingerprints on it and let it dry. You can carefully throw away the backing sheet and admire your photograph!

Once you've got to grips with your camera and the film, it's a good idea to have a little ponder about what makes a good photograph. Unless you're using one of the newer models of camera, which combines a digital screen with an in-built instant printer, you'll have to get to grips with the idea of analogue photography. Unlike digital, where you can fire shot after shot and then delete anything that you don't like, taking a *Polaroid* picture needs a little more thought. You can always take a great picture by pure chance, a lucky point-and-click moment that is just right, but you can cheat the odds of a bad photo by bearing a few simple things in mind. Getting the lighting, balance, colour and composition sorted will make a big difference to how your pictures turn out.

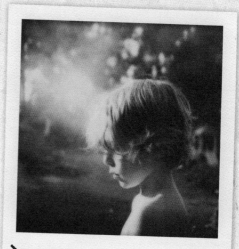

By experimenting with natural light, you can completely change the look and feel of a shot.

Let a little light in

Photography is essentially drawing with light, and even though we can't see them, there are beams of light bouncing off everything. When you click the shutter of your camera you have frozen a moment of time by recording that reflected light. So it's no surprise that light itself, from bright sunlight to cloudy days to the dark of night, has a big impact on the look and atmosphere of pictures. Indoors, mirrors and glass, with their lovely reflective nature, will give your portraits a golden look. Outside, puddles capture clouds on their surface and ponds are transformed into giant fairy-tale mirrors as the sun works its magic. Take walks in all kinds of weather and look at what the light is doing, where the shadows fall, where the world is aglow. Hold up your camera and look through the viewfinder, and try to imagine how the scene that you're walking through will look as a photograph.

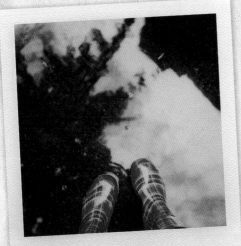

Simple ways of playing with the light can make for neat visual tricks. Try messing around with reflections and shadows to create some interesting images.

Natural light

Whether afternoon sun, shade, cloudy skies or the glare of the midday sun, the changing light will affect the pictures you take outdoors, from the vintage feel of bright sunlight to the dappled look from overcast skies.

Sunlight is the easiest, as it's outside your door, doesn't cost a penny, and, depending on the kind of day it is, can weave all kinds of enchantment – it's the light that instant film loves the best of all. Head out just after sunrise or in the hour before the sun goes down (known as the 'golden hour' by cinematographers and photographers for its soft, glowy qualities) for the best results; these times of day are the most flattering for pretty much any subject.

A sunny day with lots of cloud cover will also produce flattering pictures as the light is soft and forgiving, but beware the glare of midday as that can result in 'warts and all' portraits. To avoid those sorts of harsh qualities bring your subject into the shade, but not into complete darkness, as your lack of light will lead to a washed-out look. Front light – when the sun is behind you, shining directly on to your subject – can be harsh too, but it's great for landscapes and lifestyle and travel pictures, where you'd like the image to

Bright light will give your photos a vintage, washed-out feel, but in direct sunlight you can risk over-exposed pictures.

be clear and crisp and without shadows. Backlight, where you're shooting into the sun, will often produce very stylish light flares in your finished photograph. And sidelight is brilliant for portraits, giving a moody, film noir look. Bright sunshine produces the crispest pictures, and a little cloud cover on a sunny day can make for a lovely dappled effect, but there's nothing to stop you giving nature a little helping hand with a light reflector. They're like lightweight portable mirrors that redirect natural light, chase away harsh shadows and give a professional gleam to outdoor shots.

Black reflectors tone down unflattering, glaring natural light. A silver reflector bounces back natural white light and makes the subject of your photograph brighter, while adding a bit of contrast. It can be a little harsh, though, so if you're looking for something warmer, go for gold. A white reflector is brilliant for getting a lot of soft light on to the object of your attention. A sheet of white cardboard from any art supply shop will fit the bill perfectly, and DIY shops sell insulation panels covered with silvery reflective material in lots of different sizes, which are a cheap alternative to the real thing. Or you can easily make your own (see overleaf).

How to make a lo-tech light reflector

You'll need a piece of cardboard, some tin foil (or any shiny, reflective material you can find), a pair of scissors and some sticky tape. Cut out the reflective material, about 2.5cm/1in bigger all the way round than the cardboard. Smooth the reflective material over the cardboard, and fold the excess around the back. If you've gone for the foil option, let the less shiny side be the one showing. Turn the cardboard over, and tape down the excess material to stop it from sliding.

You'll need a friend to hold the reflector while you're holding the camera. It might take them a little bit of practice to work out how best to capture the light and direct it where it's needed most, but they should be able to see straight away that the reflector creates an aura of light wherever they are directing it. Place your subject facing away from the sun and hold the reflector close to them. Let the light bounce off the reflector and then tip and tilt it so that your subject is beautifully illuminated in the reflected glow of light.

After sundown

Night-time photography is tricky. It may seem obvious, but it's the lack of sunlight that's the problem, so you're going to have to arm yourself with a flash or flashlights to provide enough illumination. A huge moon, starry skies, street lights, urban streets busy with cars and neon shop displays will all help, but there's still the possibility that your pictures will turn out indistinct and shadowy if you don't have a bright-enough source of light for your camera to capture. As long as you're aware of the limitations, there's nothing to stop you heading for the dark side, and taking pictures that look really intriguing and mysteriously atmospheric – see page 50 for some ideas.

Indoors

Natural light indoors is lovely, but it can be a bit of a challenge for some instant films, so try to capture as much light as possible for the best results. Taking pictures by a window is a good idea; really bright light will give you harsh shadows, so think about ways to filter direct sunlight: gauzy curtains do the trick, or white sheets. An open door with light streaming in can be hugely effective too. Positioning your subject by a white background is also a brilliant way of maximizing available light. And you can always get busy with your home-made reflector (see previous page).

Candles give off a low level of light. It isn't ideal for lighting a subject, but it can make for a moody photograph on its own.

Turn it on

Artificial light is there at the flick of a switch and, as you'd expect, is a world away from the natural look of sunshine. Bright bulbs with a shade are best, fluorescent bulbs and flashcubes are unforgiving, and side lamps can be very subtle. Candlelight casts shadows on your subject, which can be a good thing as it creates mood and atmosphere, but it might be too dim to allow your picture to develop cleanly.

This is one of those times where paying attention to the look of the light can really pay dividends – move around your subject to see how the light changes, as even one side step could make all the difference to where the light falls. You might find that the play of the shadows and the light transforms a gloomy scene into something haunting.

Picture perfect

Once you have got to grips with light, it's time to consider composition –
if you're canny, you can transform even the most ordinary, everyday scene
or object into something extraordinary. And the reverse is also true: if you
aren't lucky, carelessness can make for a deathly dull photograph. So
here are some guidelines that will help you get started and boost your
confidence. You don't have to abide by all the rules in your picture: like all
rules, they're made to be broken now and again.

Square up

The first thing you can do is start seeing everything as a potential picture by making yourself a little frame of the exact dimensions of a *Polaroid* picture (a bit of cardboard will do the job), and start viewing the world through it. It will give you a very real sense of what will look interesting, and how stepping in closer, moving further away, or taking side steps would change the look of your snapshot. It'll also help you decide what to include in your shot – and what to leave out. The more you use the frame, the better you'll get at spotting a picture-perfect moment.

The Rule of Thirds

'The Rule of Thirds' is one of those ideas that sound more complicated on the page than they are in practice. Beloved of painters, it's a way of enticing the eye into a picture by imposing an imaginary grid on the scene in front of you and carefully placing the objects in your picture in the most appealing space in the shot. Imagine placing a Noughts and Crosses (Tic-Tac-Toe) grid on your potential picture, so that it's in nine sections. Then place your subject on one of those pretend lines, or on one of the points where the lines intersect, as that's where our eyes tend to focus. So, for example, you could fill the upper two-thirds of your grid with wide blue sky and the bottom third with pale-green grass, while aligning one of the intersecting lines with a mobile-phone mast.

Imagine this grid of squares over your photograph, and try to line up elements of the image so that they hit one of the lines or intersections.

Leading lines

Another great way of attracting attention, and giving a picture structure and drama, is to use leading lines. The eye likes a line; it's naturally drawn in by them. A straight line, like a road or a countryside hedgerow, will give a bold effect, while something a little curved – the meander of a river, say – will be much softer. A pedestrian road crossing, a railway track, a fence or wall, a row of columns, a stand of trees, or even the threads of a spider's web can draw you in. The lines themselves can be the focus of the picture, or they can lead you to something else of interest – a person standing at the end of a wooden pier, for example.

Frames

A frame is not just something you put your instant picture in; it can be a feature of your photograph. Imagine a bustling scene inside, a party maybe, with lots of people milling around; you could just take the picture, but

chances are it's going to look cluttered, and a bit haphazard. However, step right back, away from the scene, using a doorway as a frame, and suddenly everything is neatly contained and the whole atmosphere of the picture changes to something more intimate. Doors and windows are obvious frames, and the bars on climbing frames would work brilliantly, too. But you could also go for something more subtle: the branches of an overhanging tree, or even someone's arm or shoulder, can be just as effective.

Depth of field (DOF)

The DOF is the portion of the picture that's in focus in your photo. For landscapes the DOF should be large and wide; for portraits the focus should be on the face, with the background fading and nicely fuzzy. It's all about where you want the focal point to be. Depending on the sort of *Polaroid* camera you have, you can exercise more or less control over the DOF. Something like the vintage Polaroid SX-70 means that you can get

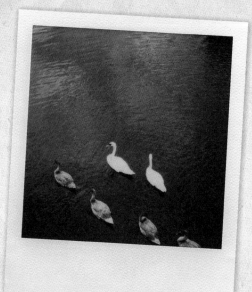

up close and personal – about 30cm/12in away from your subject – where they will be a sharp shape against a wonderfully blurry backdrop. Newer cameras have a tendency to focus everything evenly in the frame.

Positive and negative space

'Positive space' is the main subject of your photos, and everything around that subject is the 'negative space'. Usually, we concentrate on the subject, but it's worth paying attention to all the negative space that surrounds it. We are so used to the idea of what we think things look like that we often take the most obvious, straightforward shot of a subject, which can be lovely, but for something more lively try looking at the space that surrounds the subject; suddenly, you can 're-see' its shape and how it fits into the background. Negative space gives the eye somewhere to rest and it makes pictures look less crammed. So you could take a picture of telegraph wires, with little birds perched on the line, with you as close to the wires as you can get, or you could frame the wire against the wide-open sky for a really dramatic look. Negative space can make for nice visual jokes, too – try a portrait in which most of the picture is space, with the top of the head just peeking into shot from the bottom of the frame.

Backgrounds

It's always a good idea to look at the background before you press the shutter. Your picture may be perfect in the foreground, but often there's something lurking in the background that's distracting – a tree or a building that looks like it's sprouting out of someone's head, due to the angle of the shot, or even someone pulling a cheeky face in the background. So while you're focusing in on your subject, make sure that there's nothing untoward in the background.

You can also use the background to enhance the atmosphere of your pictures. A neutral backdrop, like a white wall or door, will make for a serene portrait, but if you shoot the same picture in front of a wall covered in graffiti, the picture will feel edgier and more urban, and the background becomes a part of the story of the picture.

With a little thought and an unusual twist, even seemingly dull objects can make for an interesting subject.

Other things to think about

If you bear in mind the basic rules of composition and lighting, you're already halfway towards creating a really memorable instant photograph. But there are a few other pointers that are useful to think about as well – you don't have to try to fit these into every photograph you take, but they might help to spark a creative thought, or allow you to spot a perfect 'photo op' that you may have otherwise overlooked.

Colours

Colour can really affect the mood of your pictures, so it might be worth revisiting the colour wheel of school art lessons to remind yourself about which colours work together and which colours don't. Complementary colours are directly opposite each other on the colour wheel and have a natural affinity. Other colours are quietly harmonious, and some just plain clash. Cooler colours – blues and greens – are restful; red and orange pop and create a feeling of intensity. Light and location will change the look of the colours in your picture – sunset will give everything a lovely, orange glow, while a white background will make everything soft and creamy.

Bear in mind that instant film can be unpredictable, particularly with older cameras, and the colours that you're seeing in the real world might not be the colours that appear in your picture – all part of the fun, but something to keep at the back of your mind.

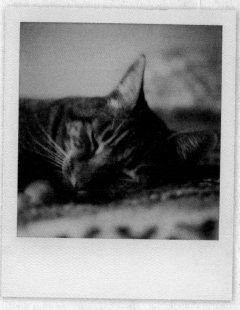

Perspective

Perspective is all about angles and viewpoints, so ditch the straight-ahead shot for something more visually interesting. Try shooting off-centre, from sideways on, or from the top looking down, or reverse that idea and see what happens when you take pictures from the ground up. Try looking at the same scene but from different angles to see how it affects the feel of your shot. Look at a picture of a sleeping pet, for example. Hop on to a chair and look down at your cat and you can feel the distance between you and it. By contrast, if you crouch down to the cat's level, or lie down to take the picture, it's a much friendlier image – a cat's-eye view of the world. See page 66 for some ideas.

Patterns

Patterns are brilliant for giving your pictures a sense of structure, harmony and rhythm, as the eye is naturally drawn to them – especially if they're recurring or are a little out of the ordinary. It could be something man-made like a brick wall, the tiny tiles in a mosaic or a parquet wooden floor; or you can explore the patterns in nature – leaves, the swirl of seeds in a sunflower, the spirals of a snail shell. Your patterns could follow a subtle theme – of circles, for example. Set the table with a polka-dot tablecloth and then group different-sized plates and cups filled with different-coloured drinks as a celebration of things in the round.

Shadow play

There's something very mysterious and enticing about shadowy pictures. Take a walk around your local environs, be that field, beach or city street, and instead of scouting interesting locations look for unusual shadows,

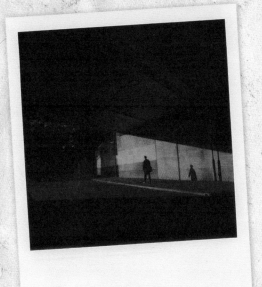

This break in the shadow draws the eye and adds drama to the scene.

to see how they can add atmosphere and emotion to your pictures. It could be the shadows of the branches of a tree on a factory wall, turning a dull building into something more magical, or a strand of trees in the park, where it looks like the shadows on the ground are reaching out of the picture towards you. For something livelier, you could take pictures of your friends' shadows, and any shadows that allow some light through will make amazing pictures – from bicycle spokes to the struts of bridges to the diamond mesh on the fences around tennis or basketball courts.

Texture

It may seem odd to talk about texture when photographs are, on the surface, flat and shiny. But you can add a tactile feel to your images, especially if you shoot using sidelighting to highlight detail; it will really accentuate the rough, fissured quality of tree bark, the scratchiness of peeling paint on old wood, or the cloud-soft brush of a flower's petals.

Odds and evens

Objects look best in odd numbers, so think odd wherever you can: three apples, five record sleeves, one electricity pylon... Even numbers are easy for the eye and brain to sort out; with odd numbers there's always one thing left over, which keeps your eye moving across the photograph and your brain interested. This doesn't apply to big groups of things or people as there's more than enough going on to keep things intriguing. Also, you can break the rule when taking pictures of couples. When it's a duo, symmetry and balance are the things to think about.

Symmetry and asymmetry

Symmetry is all about harmony and balance. It's said that, because the human body is symmetrical, our eyes are drawn to symmetrical compositions out in the world. To play with this idea, imagine drawing down the middle (horizontally or vertically – either way works) of your picture – the two portions should look roughly the same. It doesn't have to be a mirror image, but there should be a certain equilibrium. A tree-lined street, the reflection of buildings in water, the view from the top of a spiral staircase, two people standing a little apart in similar poses – all these would showcase a sense of symmetry.

But sometimes you want to turn the notions of order and balance on their heads and create a startling image. If you're looking to create tension and drama, you can achieve this by taking a picture of a symmetrical building from an odd angle, disrupting the pattern and making the building really stand out from the background. Try an off-centre stance. And you don't have to be looking at a building: pretty much anything can be given an asymmetrical attitude.

Eye spy

If you're ever stuck for inspiration, then try to remember that with the right mind-set and a creative eye you can take a photo of just about anything, from urban tower blocks, flyovers and industrial factories to seascapes, people, trees, graffiti, sparkling water, bicycles, bookshelves...

The list really is endless: you just have to look around you. And the more you look, the more you'll see!

Getting creative

Once you have a grip of the basics, there are all sorts of fun projects for you to try out with your *Polaroid* camera, from lo-fi filters to more offbeat ideas. Here are a few suggestions to get you started.

Create your own photo-booth strip

Before the age of the digital camera or smartphone, instant photos were available from two sources: a *Polaroid* camera, or a photo-booth. A photo-booth would deliver a strip of four pictures, one on top of the other, and was a great place for friends to get quick, easy and fun photos of each other. So why not recreate that retro photo-booth magic with your own *Polaroid* camera?

Try creating a strip of face-on portraits in the classic style of the passport picture (but hopefully more flattering, as you'll have more time to compose the shots). Find a background that's uncluttered, so that you can focus on your subject's face, rather than being distracted by a busy background – a warm-coloured brick wall would be a good backdrop outside, or a painted wall indoors. Then take four photographs in a row and line them up one on top of the other to create the vintage photo-booth effect.

You can play around with this project, too. Suggest that your subject try out their acting abilities by pulling four hugely different expressions in the four photos, or get them to pretend that they're reacting to something outside the shot – the sudden appearance of a ghost, a surprise marriage proposal or the last scene of the world's saddest movie.

Try a full-length portrait: in your mind, divide your subject in four. Take a picture of their head, then lower the camera and take a picture of their torso. Take one of their midriff and finally one of their legs and feet. Assemble the *Polaroid* pictures into a photo-booth strip to make a whole person.

And you can always recreate that photo-booth staple, a scramble of friends changing position every time the light flashes. It might be difficult to direct the participants, but that's part of the fun. If you're really struggling, you can try a version of musical chairs with you shouting 'STOP!' before you press the shutter.

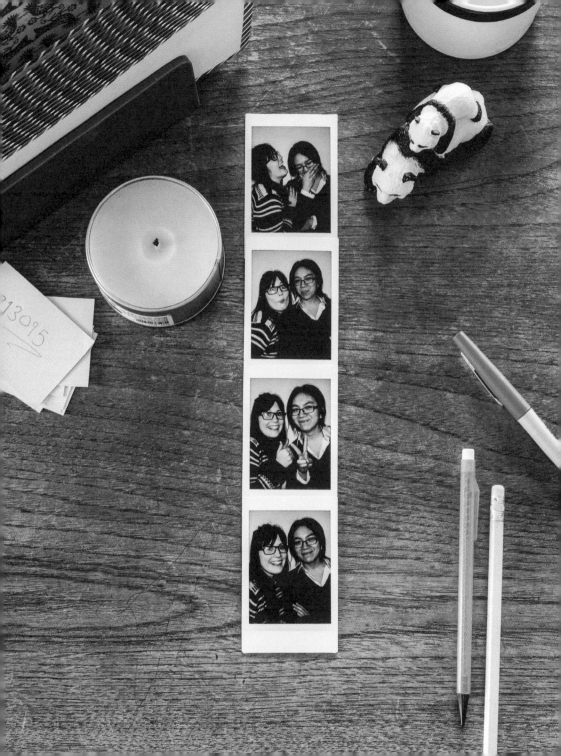

Up close and impersonal

There's a world of visually interesting things that we don't take the time to notice – from keys to bicycle cogs, sneakers to jars of nail polish. They're always there in the background, but if you look closely you will start to notice how detailed and intricate some of them actually are.

So try taking a series of pictures that elevate the mundane to the magical. Decide on which everyday object you're going to celebrate – bicycle cogs or spokes, for example – and then have a good, close look at them. You can take some stylish straightforward photographs, but a sequence of extreme close-ups would look even better – the intense sense of focus transforms them into something abstract and brilliantly strange. (If you're using one of the classic *Polaroid* cameras, then you may need to use a close-up lens to get some of the really close details.)

You could concentrate on finding patterns in the components, and then make a collage of your most striking images. Or you could attempt to make them look like something else entirely – a piece of modern architecture, with the cogs and spokes reaching into the air, or segments from some kind of futuristic machine.

You can also be just as abstract and inventive with colour. A heap of jellybeans or a row of bright nail polishes can become a Technicolor marvel; sort your subject into rows of different shades, changing from a blur of peach, to red, through to yellow. Try photographing them up close and from different angles to create something unique and otherworldly. Playing around with different lights and angles can turn your everyday, ordinary objects into extraordinary *Polaroid* pictures.

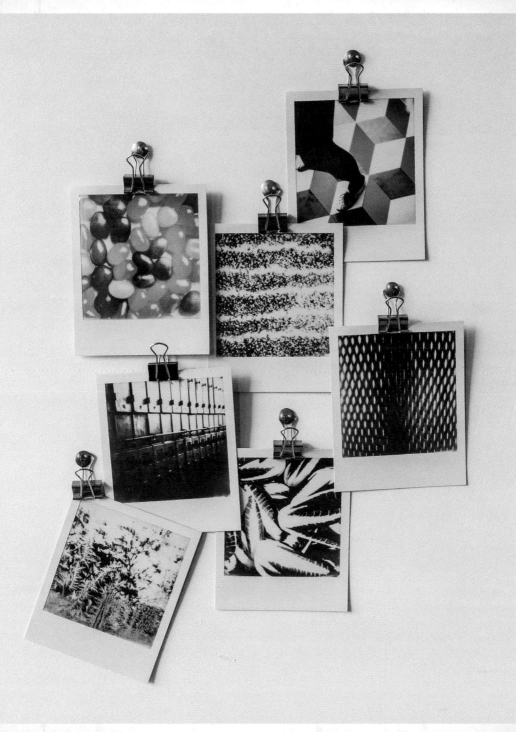

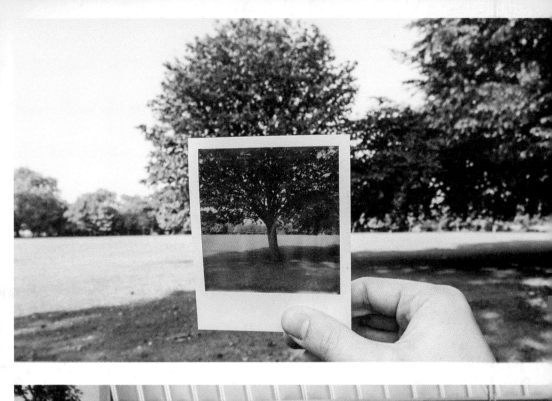
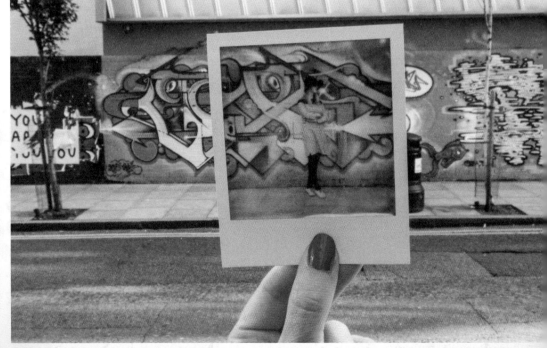

Frame within a frame

A photo within a photo is a quick and easy visual trick that can be used to create quirky pictures. You can snap a person, place or thing, though the more distinctive the location the better the picture will be. You're going to need one instant *Polaroid* camera, a spare camera or a phone, and a steady hand (or a helpful friend).

First, find your subject – it can be anything from a plant pot or a park bench to a sleeping cat or your friend striking a pose. Carefully line up your instant shot, make a rough note of where you're standing, and then go ahead and take your picture. Let the image develop.

Step back a couple of paces and hold up your developed *Polaroid* photo, so that it seamlessly blends in with the original background. This is the one time that the 'no fingers and no thumbs' rule doesn't apply; you need to see them proudly clutching the edge of your *Polaroid* photo.

Take your other camera or phone and carefully frame the instant photo in the viewfinder (this is where a friend can come in handy, as it's tricky to hold your *Polaroid* picture in the right place while you line up the second camera just so). When you have everything in place, press click … and voilà! A really simple way of creating a neat visual effect.

Other ideas to try:

�֍ When taking your photo, try having your subject interact with the wider background – seeing someone engage with the scene beyond the *Polaroid* picture can work to great effect.

✖ It can be fun to come back to the same spot at a later time or in different weather, so that your two photos have a completely different look and feel.

✖ If you have a friend to hand, you can try including more than one *Polaroid* photo in your picture to create a collage effect.

After dark

A sunny day and a *Polaroid* camera will work all kinds of magic, but a different kind of spell is cast after dark, where the world is shadowy, the light is sporadic, and the look of your snapshots will take on a completely new atmosphere.

You'll need some form of artificial light in order for your camera to pick up the image that you're trying to photograph. If you're photographing objects in close-up, you'll be able to light the shot yourself, whether with the flash bar found on older *Polaroid* cameras or the built-in flash of the newer models, or a good old-fashioned flashlight. Or you can head out on a night-time quest in search of other sources of light, from streaking car headlights on busy roads, to bright big-city neon. Street lamps, bright shop windows and cafés throwing light on to the pavements all make for intriguing scenes, and can create wonderfully evocative instant pictures.

Though you will need quite a bit of light in order for an image to turn out perfectly, even low-light situations can make for fascinating photographs. Seek out a sunset or a city skyline, twinkling with lights, and you can create moody, painterly photographs if the light is right – so play around and discover what works best for you.

Other ideas to try: �֍ Take your photo by the glimmer of a lit sparkler or celebratory fireworks or by the flare of a bonfire on the beach to create lovely, blurry, enigmatic pictures.

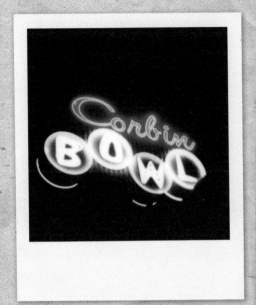
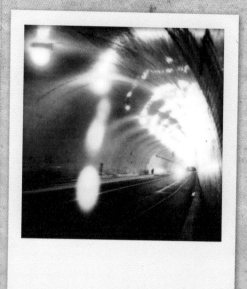
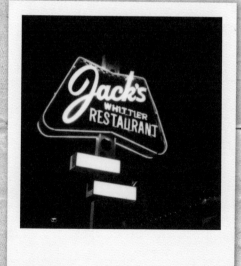
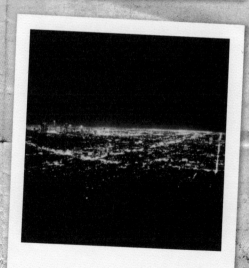

Broken collage

Pop artist pioneer David Hockney turned to *Polaroid* pictures in 1980. He was working on a painting of a living room and took some test shots on his instant camera, then glued them together to create a *Polaroid* photomontage. He immediately saw the appeal of this technique and made a series of mosaic collages of people and landscapes, moving his camera in sequence across his subjects to create a series of photographs that pieced together to form a bigger image, a bit like a giant *Polaroid* jigsaw.

So be inspired. Instead of taking a straightforward image or portrait, make it a more fragmented affair. First find your subject – something colourful and bright would be a good starting point, maybe a fairground carousel, or an album with a nice-looking sleeve or label. Look at your subject and mentally divide your potential picture into thirds – a shot of the right-hand side, one of the left-hand side and a final one of the lower middle. Carefully take the three pictures, let them develop and then piece your *Polaroid* photographs together to recreate your subject in full.

Once you've got to grips with the technique you can expand your repertoire. The pictures can be snapped at slightly different angles that will give the finished collage a more abstract, Cubist look. Or try taking a series of close-ups for a kaleidoscopic feel.

A grid of *Polaroid* pictures is also impressive, if a little more ambitious – you'll need to take at least nine photographs and recreate your image in a three-by-three-square grid. You can either stick to a rigid grid, or go for something more free-flowing: instead of shooting subjects in a grid and assembling them into a frame, let the theme of your subject dictate the shape of your collage. So if your subject is a person, then make your montage human-shaped; if it's an oak, make the end result tree-shaped.

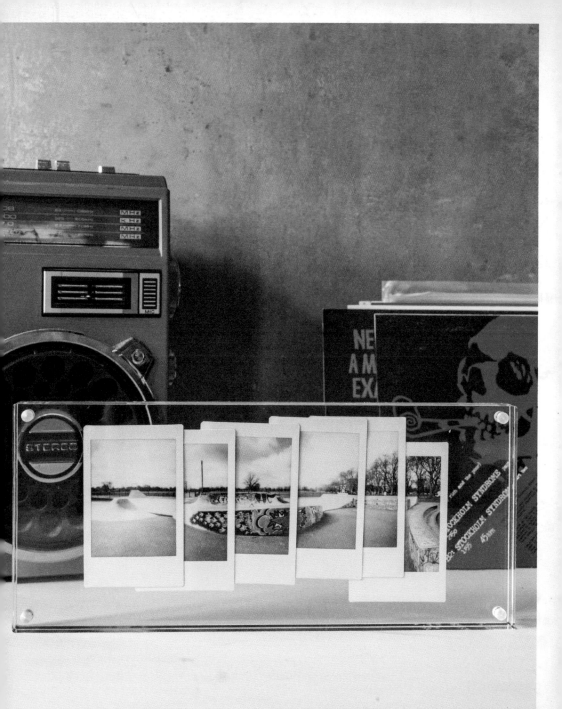

Mapping a journey in pictures

Maps and photographs are great mediums for exploring the world, so why not combine the two? Take a road trip or holiday, or simply head out on foot, by bike or by bus and snap the landmarks and the sights that mean the most to you on your journey. It could be your favourite spot on a holiday or some local landmarks like your local library, a particularly picturesque lighthouse on the shore, or just your favourite café.

The nice thing about this project is that it's so adaptable. You can follow a route that's really familiar to you, or take an entirely different direction and see what you discover. It could be a large-scale journey – think countries or continents – or a very small area – the distance from your home to the local park. You could head back down memory lane and create a photomap of special locations from your childhood or scenes from your teenage years.

Back home, unfurl your map and pin your *Polaroid* photos to the locations where they were taken, to create a visual memento of your journey. It can be a bought map – even the most standard street map can be beautifully detailed – but for an added twist you could create your own, and annotate your *Polaroid* photos with memories of your trip.

Other ideas to try:

❊ Revisit your map journey at different times of day or night or in unusual weather to see how it changes the look of your landmarks. Take more pictures to capture the change in atmosphere.

❊ Find a reprint of an old map of your hometown. Choose sites of interest on the old map, and head into the modern world and take photos of what's there now. Pin your new pictures to the old map.

❊ Instead of an outdoor map, you could take an indoor voyage, a photographic journey around a room or a house. It can be a nice way to remember a favourite place when you're away.

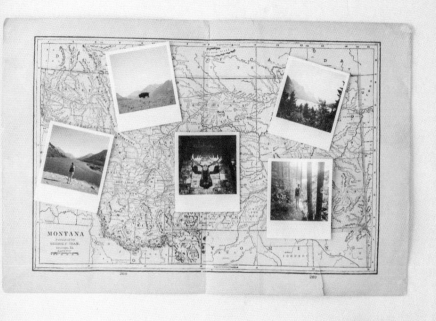

Interactive *Polaroid* pictures

Your instant photos don't need to be a solo affair – you can have a lot of fun breaking the border and creating interactive *Polaroid* pictures, too.

You need at least two people (though you can add more into the equation) and an 'action' that is participatory. So if you're feeling romantic, take a picture of yourself in profile puckering up for a kiss – it can be a selfie, or you can get a friend to take the shot. Get your sweetheart to do the same, but in reverse, then line the pictures up side by side, so that it looks as though you're both about to kiss each other. You could do a whole series of kiss-me-quick shots, with a different background in each of the pictures; it could be places of interest in holiday locations, or familiar locations in your local town. And if you happen to be in different countries or are far apart for some reason, you can make it a little keepsake, sending kisses from wherever you are in the world.

Or you can abandon the allure of love for something a little less slushy and go for a handshake, or even a fist-bump. You can keep it nice and simple, a 'pleased to meet you' across neutral territory, or you could make it more dramatic, with the pair of you reaching across rivers, through hostile environments, over sudden drops or through walls.

You can continue the 'pass it on' theme with a shared secret, so one sly soul pretends to whisper into a curious ear, while in the next picture the intrepid listener cups their hand to their face, ready to catch the hushed words of a secret. If you're in celebratory mood, you can toast the occasion with a clink of glasses or bottles and a raised cheer.

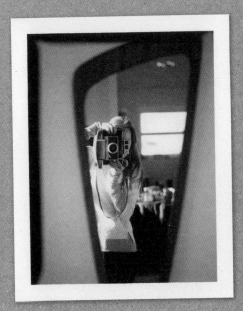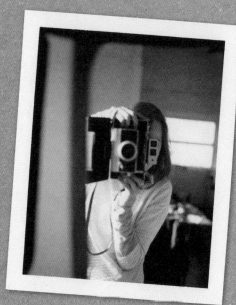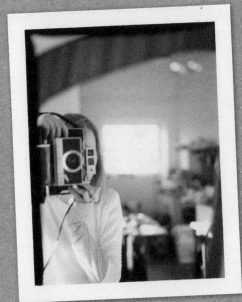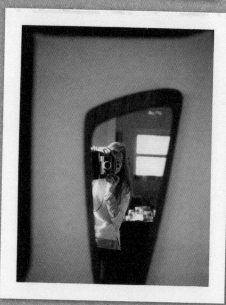

Selfies

Polaroid cameras are perfect for stylish instant selfies. You can use a mirror to show off your camera, a shutter remote for a flawless look, or the old-fashioned hold-the-camera-at-arm's-length approach for a fun, more spontaneous style.

If you're going for the mirror approach, get yourself in position and have a good look at what you can see in the mirror. Is there anything in the background that's going to clutter up the shot, or is the busy, cluttered look what you're going for? Is there enough light? Do you want to be centre-stage, or slightly to the side? When you're all set, hold your camera very steady to prevent blurriness and then take the picture of you and your lovely camera. It's easiest to look through the viewfinder as you take your picture – though, obviously, this will mean that you won't be able to see your face. If you'd prefer to hold the camera lower so that your face is visible, take the time to make sure that you're angling the camera correctly to get the perfect shot.

If you're going for the camera-at-arm's-length option, check all the things listed above and then strike a pose. If you hold the camera slightly above your head, you'll get that big-eyed Bambi look, and turning your head a few degrees to the left or right will make your face look less flat in the photograph.

With a shutter remote or a self-timer the world is your oyster. You can set up scenes, squeeze in as many props as you like to surround you, take full-length shots and generally let your imagination run wild. On the technical side it's best to set your camera up on a tripod, but a stack of books, a table or a wall will do the job, too. Get behind the camera and think about your shot. Once you've worked out where you'll be in the picture, it might be a good idea to pop an object into the scene as your stand-in, so you've got something to focus on while you get the shot set up. When it all looks good in your viewfinder, step into your backdrop, and press the remote shutter. Once the picture develops, get sharing your *Polaroid* selfie!

Signage, logos and labels

There are signs everywhere once you start to look, from the bright, shiny ones on shops and restaurants to the ghostly painted ones that appear when old buildings are being renovated. On a smaller scale, but just as interesting, are the logos and labels on everyday items, from giant cans of olive oil and tins of coffee beans to the labels on independent records and imported sweets in international grocery stores. Brilliantly designed, and often with a smart, retro vibe, they make perfect subjects for a personal *Polaroid* photographic project.

Try an exercise in nostalgia, capturing old signs from local cafés, stores, theatres, or traditional butchers and bakers, and display your photos in a panorama of shop fronts. Or you could snap an array of neon signs – creating a Las Vegas look, even if you're far from Nevada.

With logos and labels, it's all in the detail, so look out for the most intriguing, graphically interesting examples that you can find. Odd colours, bold lettering, strange fonts and beautiful illustrations can make for perfect pictures for your personal collection. It's worth trawling through shops that are off the beaten track and checking out the offerings on their shelves, from imported food to local craft goods; or head to charity shops and thrift stores for old vinyl records, board games and books.

Make a collage of the most unusual and striking snaps. The collage can stick to one theme – an assemblage of appealing foreign food labels or a collection of neon signs – or you could group them by colour and shape.

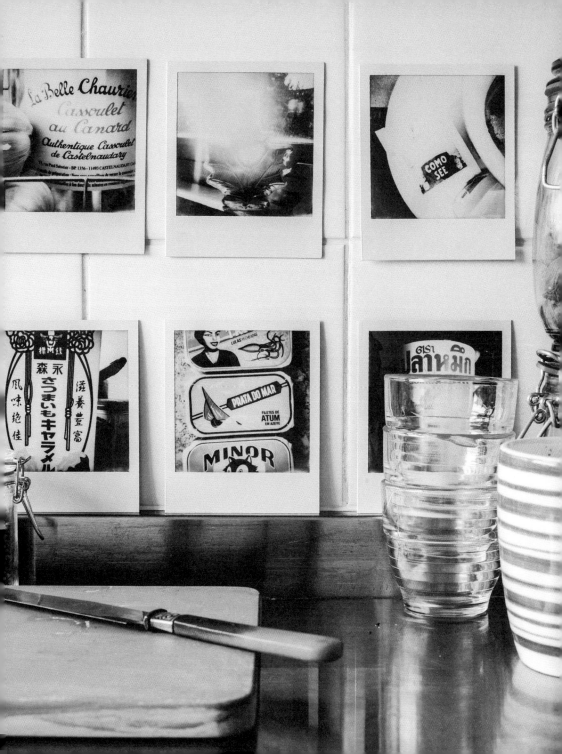

Back to the future

A very fun way to harness the retro style of old *Polaroid* pictures is to bridge the gap between your very favourite old photos and the pictures that you snap with your *Polaroid* camera today.

Why not delve into the family photo album, or dig out an old picture of your friends, and attempt to recreate your own piece of history. Choose a photo to re-enact, return to the original location (if you can – if not, then anywhere that looks similar will do), strike the same pose and snap away. Display the original picture side by side with the new version for a fun look at how time has passed.

You can take a fairly relaxed approach to this project but, if you want to go all out, you'll find that a big part of the fun will be getting your 'new' *Polaroid* picture as similar to the original as you possibly can. Head to charity shops and thrift stores for suitably retro clothing, or look online for vintage glasses, jewellery and props. Use your charm to persuade the participants to revisit old hairstyles and get them to practise their expressions and poses from the original pictures.

You could do the same with your pets – recreating images of cats from their kitten-hood, for example – to see just how much they've grown.

Other ideas to try:

✻ You don't have to limit yourself to old photos: you could recreate an iconic album sleeve, or the jacket of your favourite novel.

✻ Or why not go for a famous scene from an iconic movie – channel your inner Audrey Hepburn or strike your best superhero pose.

✻ If you're feeling really ambitious, you could try a painting. A shadowy Old Master would be very impressive, but so would Van Gogh's *Sunflowers*.

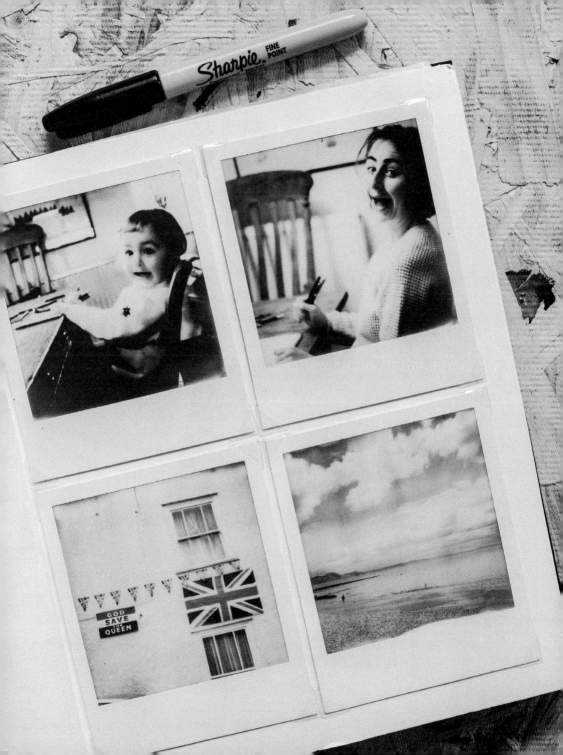

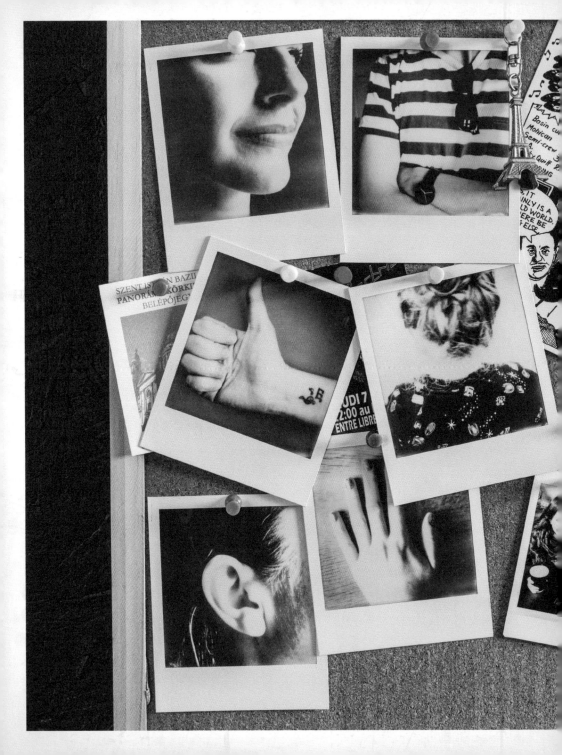

The portrait gallery

A portrait of a family member, friend or pet is a lovely keepsake, and an instant camera is the perfect way of capturing those personal moments – the *Polaroid* photograph is taken, printed and developed while you're together.

You could start a collection of these moments, capturing your favourite people or pets in different moods and all kinds of locations and weathers. The best portraits not only show what people look like but tell you something about them as well – they reveal a glimpse of personality and character, so decide on the best way to capture that.

It could be as simple as a traditional face-on study, with flattering light and your subject sitting still while you take their picture. Get them to sit on a wall, lean on some railings or perch on a chair – whatever you feel suits them best – and make sure that the sun is behind you and that there's a little cloud cover, as too much bright light can create a harsh portrait. If you're indoors, your subject should face the light so that it illuminates their face. Don't be afraid to get up close, focus on their eyes, and, if they're nervous, talk to them until they relax a little. Try different poses: ask them to turn their head to the side or have them look over their shoulder. Add a prop into the equation – any object that represents something important to them, whether that's a skateboard or a bunch of flowers fresh from their garden.

If that all feels a little artificial, try taking 'candid camera' shots, in a relaxed situation without any posing; maybe an action shot of them running or spinning around in the sunshine. This more relaxed approach can lead to slightly blurry or imperfect images, but that can be very atmospheric, too, and part of the moment.

Or another interesting approach is to abandon the traditional approach entirely, and go for a more oblique portrait, taking a snap of an ear, a pair of glasses, some painted nails or a tattoo; sometimes a small, telling detail that means something to you can be as revealing as a picture of their face.

Playing with perspective

Perspective is all about viewpoint. Some of the time you'll want to keep things on the level – working out the best way to take a straightforwardly beautiful shot – but it can be fun to play around and take a more adventurous approach.

Head out on to the urban streets or the grass verges of the countryside and pick a subject – towering buildings, an escalator or steep staircase, or a sunflower. Get as low to the ground as possible and then take a picture from ground level, looking up at the subject. If you're in the countryside, you could lie flat out, and point the camera upwards at that sunflower; suddenly, the scale is transformed and it becomes a huge, almost abstract form. Out in the streets you will want to avoid stretching out on the pavement, but you can still point your camera upwards to get the feeling of a building endlessly heading for the sky. An oblique angle at the foot of a set of stairs (a spiral staircase would be especially effective) or an escalator can produce a startling feeling of unease, and a thistle snapped from the ground up can look suitably menacing.

Now reverse the process, and take *Polaroid* pictures from the top down. Head to the highest window of the building or the last step in the stairwell, or take up a looming position over a sunflower and see how the picture changes when you look down. (Take care when you do this – be sure to find a safe viewpoint, secure your camera in place with a strap and don't be tempted to lean out in order to get a better shot.) The higher you are the more vertiginous the view, and the stranger the world looks, with the pavements a long way off and the buildings dropping away. It would look particularly striking at dusk, when office lights are on and shops are aglow with neon. In the world of plants your top-down perspective will remake the world in miniature, with you towering above.

Very tall buildings often have a public café or viewpoint at the top – a great place to grab a good angle!

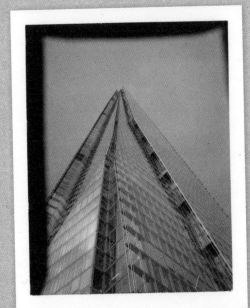

Reversing the technique and looking from the ground up gives a building an imposing menace.

Sevens – your week in pictures

You may have heard of people trying the '365' photo project. It's an ambitious one: the idea is that you document a period of your life by taking one picture every single day for a full year. It's quite an undertaking, but you can get a taste of the experience by letting seven be your magic number instead.

In this altogether speedier version of the project, you take a *Polaroid* picture every day for seven days. It could be an entirely random bunch of shots that just take your fancy when you're out and about, or you could take pictures of events and sights that are meaningful to you. If this feels a little random, you can add a theme to provide structure – so, for example, you could take a picture at the same time and at the exact same place for the seven days.

A fun approach if you're a foodie is to snap seven meals in seven days. Think about ways to make the food look appetizing or intriguing – maybe include a spoon ready to scoop up some ice cream; a bowl of soup could look boring, but sprinkle on some fresh green parsley as a garnish and a swirl of oil and you've added shape and colour. Experiment with camera angles before you take the picture, too. Does it look best if you shoot from above, or side on, or from a lower angle?

A fashion theme is a good one, too: snap a week's worth of outfits to create an album of your style. Take mirror selfies of you wearing your look, or lay the clothes out before you put them on. Try focusing on details – the lovely buttons on a vintage cardigan, the print on a dress, or the sheen and patterning on a pair of polished brogues.

There's a whole world of inspiration out there: a week of skies, seven days of flowers, portraits of seven friends in seven days, a week of buildings or artworks or album sleeves. The list is endless!

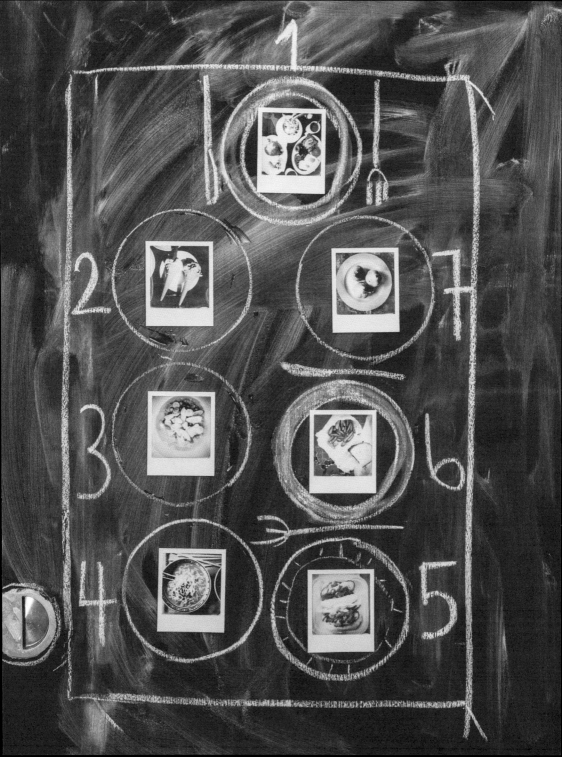

Lo-fi filters

For some, the beauty of *Polaroid* cameras – especially some of the classic models – is the unique light that they create in photographs. But it can be fun to play around with some simple DIY filters if you want to create something a little more off the wall; anything translucent is worth experimenting with and can produce brilliant, unexpected results.

First up, don't ditch any used bit of film negative from other projects. Instead, try popping it in front of your *Polaroid* camera lens while you take a photograph; the negative effect can make your picture look dreamy, and subtly change the colours of your subject. Coloured plastic acetate is easily available from arts and crafts stores and can create fantastic effects. For a green glow – think Sixties sci-fi movies, or the Emerald City in the *Wizard of Oz* – just hold a green sheet of plastic over your lens.

Even your sunglasses will play tricks with the look of your photo, introducing a sepia-toned, vintage feel when held in front of the lens. For more of a soft-focus feel, stretch brightly coloured tights over the lens.

Experimentation is the name of the game here, and it can be fun to try out the effect of anything that will alter the light in front of your camera lens. You can even try salvaging the crinkly cellophane wrappers from sweets to make an off-kilter kaleidoscope filter – the end results won't be strictly professional, but they will be interesting.

Other ideas to try:

�֎ Hold a magnifying glass over the lens for DIY zoom effects. If you take your time to get the focus right, then ants, small flowers and specks of glitter will suddenly loom large.

✤ If it's a wet day, something as simple as taking photos through a rainy window will give a strange liquid look to your *Polaroid* picture.

Frame by frame

Shooting moving subjects can make for fantastic photographs, but at high speeds it can require a lot of trial and error before you get the results you want. As an easier way of achieving similar results, you can capture a sense of movement and energy by creating a frame-by-frame *Polaroid* filmstrip or storyboard.

Have a think about what kind of scene you want to shoot – anything from a moody sequence of stills from a film noir to a skateboard trick or dance sequence. This is one of those occasions where careful planning will pay dividends, so it might be worth sketching out what you hope will happen in each shot, from start to finish.

Think about location and how this might have an impact on the mood; for example, if it's noir you're after, pick somewhere mysterious, where you can create extra drama with the play of shadows and light. Discuss the plan of action with your subject (this is where a sketch might come in handy) and, if necessary, have a practice run-through.

Have your subject pose and take the first shot. Once you're happy with the photograph, have your subject move to the next position in the sequence and stay still while you take your second picture. Continue this process until your sequence is complete. Though the photographs should look as though they were taken one after another, you can take your time to get each one set up – as long as you don't lose your place.

Once you've taken all of your photographs, let them develop, then lay them out side by side to see your very own action sequence take shape, frame by frame.

Create your own photo-booth

Add extra fun to a celebration, be it a wedding or a birthday party, by setting up your own photo-booth – an instant camera means that people can see the results there and then, and it makes a brilliant, hassle-free way to create personal mementos of an occasion.

All you need to do is assemble props and any fancy-dress items you can find on a table somewhere near a wall (so that people will have a background to pose in front of). Leave your *Polaroid* camera and film nearby, write down any instructions to guests and let the action begin!

Beyond the basic set-up, pretty much anything goes, and you can tailor the props to suit the occasion and your own style – old lampshades that double as hats, fake moustaches on sticks, a treasure chest of glamorous fashion accessories. Capes, masks and fancy dress are always popular and make for great photos.

You could also construct a backdrop to add to the atmosphere, from the simple – a plain wall or curtain, an old empty picture frame or some coloured hearts made from cardboard – to the more complex, such as painting a huge piece of paper or cardboard with blackboard paint, and leaving some chalk for people to create some erasable graffiti.

Once all the film has been used, rescue your *Polaroid* camera and gather up the snaps. You can pop the pictures in a big glass bowl for guests to dip into and laugh at, or you can create a unique guestbook to help you remember the occasion.

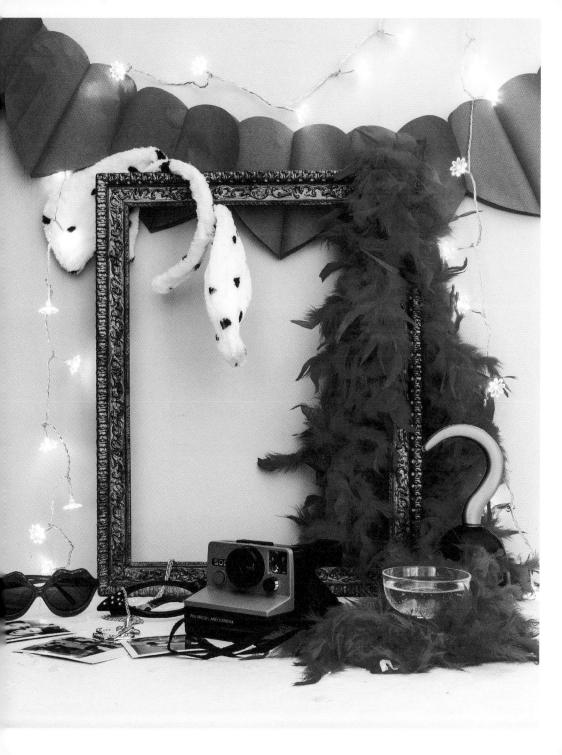

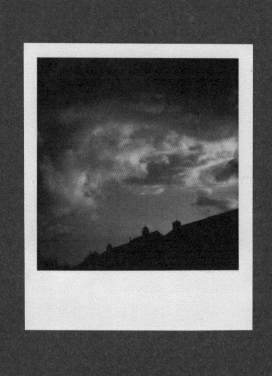

Finding inspiration

You've got your camera and you're ready to go – all that's missing now is that final spark of creativity. There are so many exciting things to shoot on *Polaroid* cameras that it can be tricky to know where you should start. On the following pages are some inspirational mood boards of photos grouped by simple themes that anyone can try out.

Vintage

Anything with retro styling will look fantastic on instant film, but cars are particularly photogenic. With their smooth curves and polished metallic shine, they're a classic subject for you to get to grips with.

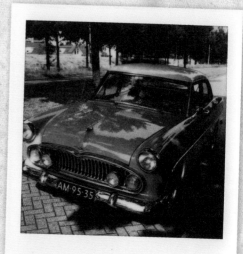

Escape

Instant photography can be a way to help you escape the hustle and bustle of everyday life. Take your *Polaroid* camera to your favourite secluded spot, or try to find a peaceful haven in the city. Or simply look up; the sky is an ever-changing subject that can yield fantastic photographs.

Shades

Think beyond shapes and forms, and set yourself
a project based on a particular colour or hue.
From fiery reds to cool blues, a group of instant
photos showing the same colour can look great
on a wall, or instead try to create a rainbow of
brightly coloured shots.

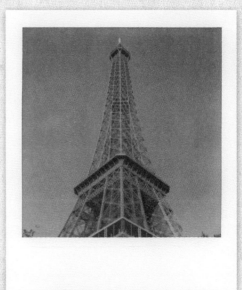

Urban

Cities are full of inspiring images, from edgy graffiti and bright market stalls to busy main streets and even dark alleyways. Take a walk around the city with your *Polaroid* camera in hand and you're sure to find something worth snapping.

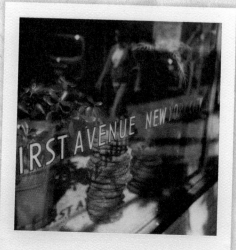

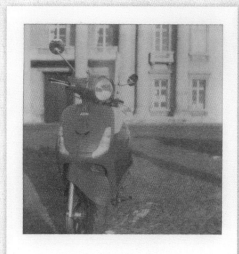

Flowers

For a less gritty approach, you can turn to nature for inspiration. Flowers come in all shapes, sizes and colours, and can make for an impressive photo collection. Go in close for detail shots, or pull out for a wider view.

Shapes

Giving yourself a more abstract theme can lead to some really exciting collections. Ignore the subject matter and look for particular shapes; circles, for example, can be found everywhere if you look hard enough, and make for a striking series of photos.

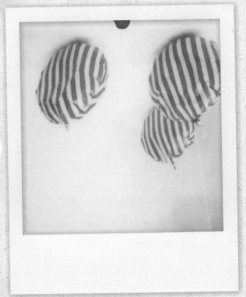

Patterns

Pattern is another theme where you can really let your imagination run wild. Keep it nice and simple and shoot pretty plates, rugs or fabrics that you see, or think outside the box and look for the more obscure patterns that would normally pass you by.

Relax

This is a perfect way to create a really personal *Polaroid* photo collection. Take a series of photographs of the things that you find most relaxing – whether that's a quiet spot in the park, a favourite novel or the musical instrument that you love to play.

Displays

Taking your *Polaroid* pictures is only half of the fun – once you're happy with your photos, there are all sorts of interesting ways to show them off. From easy ideas for displaying them in your bedroom to fun suggestions for bringing some *Polaroid* magic to parties and gatherings, here are some ideas for you to try out.

On the line

Using garden twine or old-fashioned parcel string with wooden clothespins is a brilliant way to display your cache of *Polaroid* photographs, and can be personalized to suit your style.

You'll need to pin the twine firmly to the wall (picture hooks, thumbtacks, drawing pins or nails will all work). Make loops at each end of the twine and push the pins through them, or wrap the twine around the nail and then push them into the wall. Keep the twine tight and straight for a retro drying-in-the-darkroom feel, or allow it to drape loosely like summer bunting if you prefer. Then simply clip your pictures in place!

To pretty up your photo line, swap the twine for some vintage lace or ribbon, and for an extra pop of colour you could paint the wooden pegs or buy brightly coloured plastic ones. You could even abandon the pegs entirely and go for the more urban, industrial-looking bulldog clip or that office essential, the humble paperclip. If you're after a more punky look, safety pins spiked through the top of your picture and then fastened on to the string will look suitably edgy.

You can also ring the changes by the way you pin your images to the string. Nice and neatly, with the pictures the same distance away from one another, will bring a sense of order, but there's nothing wrong with a little chaos and a more haphazard arrangement. You could hang the photos by their corners for a more askew look, and you can mix things up even more by arranging different sizes and shapes for a bit of devil-may-care flair.

There's nothing to stop you annotating your photos, too. Keep it plain and simple, or add an air of mystery with an intriguingly odd caption.

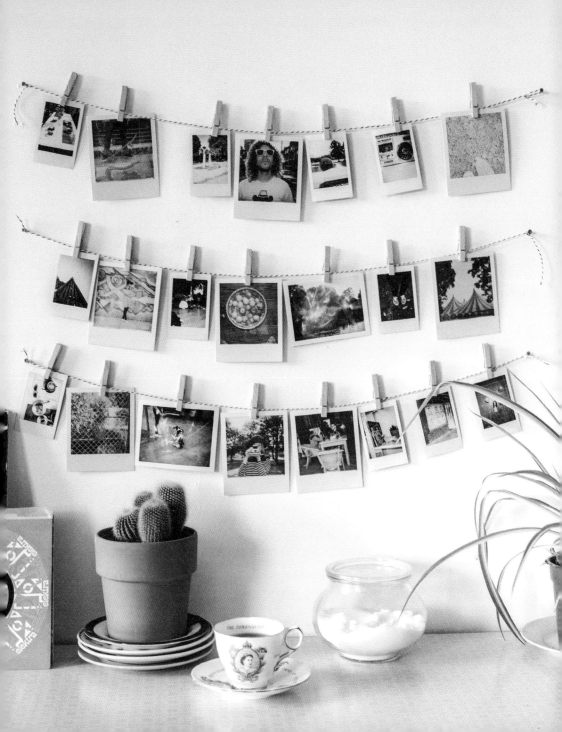

Rogues' gallery

All mansions and museums have them – a collection of portraits lining the walls of a long corridor or hallway. So why not try recreating your own version of this? Use a handy wall at home and some fun portraits of your friends or family to create your own rogues' gallery.

First you need to assemble some portraits. They can be selfies (see page 59 for tips on taking the perfect self-portrait), or pictures that you've taken of your friends, family or pets. Then decide what look you're aiming for. Matching frames of similar sizes will bring a sense of order and sophistication, or you can use a variety of sizes and styles for a more mismatched effect.

If you're thinking of an aristocratic gallery, you will need suitably antique-style gilded frames. You could strike it lucky and find something golden and ornate online, at garage sales or in charity shops, but remember that cheaper plain frames can easily be transformed with a lick or spray of gold paint. Or you could go for an even more DIY effect and use paper, permanent marker and tea bags by following a few simple steps:

Draw a series of picture frames on to paper with the marker. Dip a few tea bags into some hot water, and then 'paint' a wash of tea on to the frames, using the tea bags. You might need to do a few washes for a really antique effect. Let the frames dry, then stick a *Polaroid* photograph in the centre of each, and arrange them in a dashing display.

A more rebellious take on this idea is to create a series of police-style mug shots of your friends and family. Choose plain frames, use black paper as a backdrop to the photographs and ask your subject to pose in a suitably shady fashion. For an added touch, you could always post a description of their 'crimes' underneath their mug shot. Is your friend famed for never buying a round of drinks? Or is your dog guilty of chewing expensive shoes?

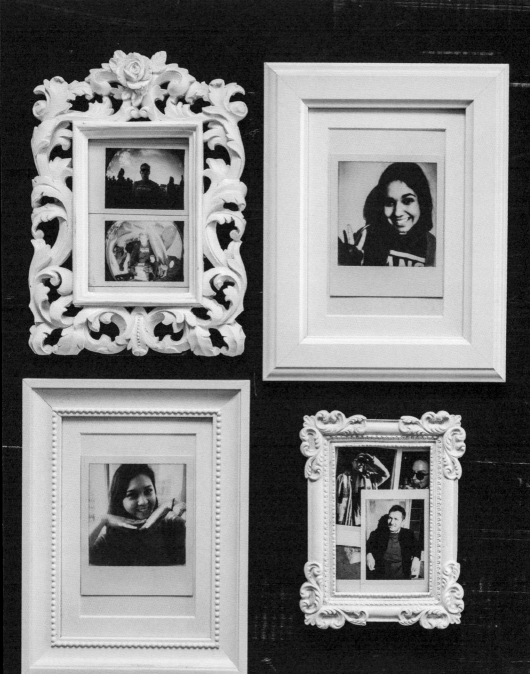

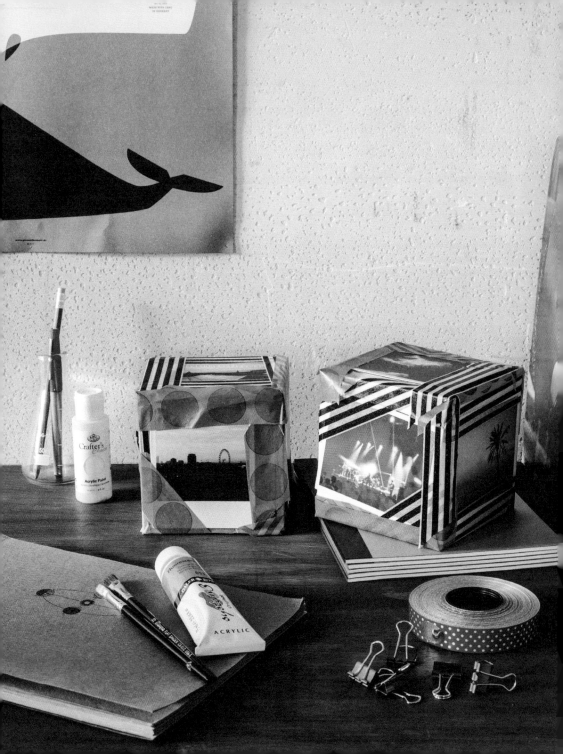

Squared

Photo cubes were all the rage in the Seventies, in the days of flares and shaggy perms. Embrace that retro vibe with your own version of the vintage classic by building a cube out of cardboard and sticking your *Polaroid* pictures on to it (flares strictly optional).

It's a little tricky to master this technique, so have a practice on some scrap paper first. You'll need six of your favourite *Polaroid* pictures, plus a piece of paper, a pencil, some scissors, a ruler, some cardboard and a roll of sticky tape.

On the paper, draw a square, making sure that it is large enough to fit your chosen *Polaroid* photos in the middle. Cut this square out and use it as the template for the next step.

On the cardboard, draw a tower block of four squares, on top of one another, using the ruler and pencil. On the second square from the top, draw another square on both the left-hand and right-hand of that square. You should now have a cross shape made of six squares. Cut the cross out and stick one of your *Polaroid* pictures in the centre of each of the squares. Fold the cross into a cube with your photos on the outside and carefully stick the sides together with sticky tape to complete your photo cube.

Put the cube somewhere easily visible, and rotate it every now and then to change the pictures to suit your mood.

Other ideas to try:

✣ Using coloured cardboard and sticky tape is an easy way to brighten up the display.

✣ It's even more striking if you make a stack of cubes and swap them around now and again.

Wall collages

A wall covered in your favourite *Polaroid* pictures will look absolutely amazing. Grids are always stylish, but you can embrace chaos with a more ramshackle approach if that's more your style.

You're going to need something to stick your pictures to the wall with, and as every wall is different it's a good plan to do a small-scale experiment to see which works best for you, and doesn't damage your wall. Avoid run-of-the-mill sticky tape as this will just peel off after a short while. Instead, try Blu-Tack, artist tape, doubled-over masking tape, coloured drawing pins, thumbtacks or photo clips (tiny, clear fasteners used to clip pictures together, perfect for collages and easily bought online).

Once you've got to grips with your chosen method of sticking, it's time to get stuck in to the collage. You might want to lay your photos out on the floor to work out the best look. Take your time, and keep moving the photos around until you're happy. Then go to work on the wall.

If you're going for a neat grid of *Polaroid* pictures, it's a good idea to get busy with a ruler and some masking tape so that things won't go wonky – use the masking tape to create guidelines on the wall to keep things on the straight and narrow. If you're after a more chaotic approach, you can just stick your photos on to the wall any way you like, but it works best if you imagine a large frame around your collection of pictures; that way, your arrangement will look deliberate and not just slapdash.

Other ideas to try:

✣ If you don't have a suitable wall or a big stash of photos, you can apply the same approach on a smaller scale using a large picture frame.

Wheelie great

An old bicycle wheel makes a stylish alternative to a traditional frame for showing off your *Polaroid* photographs. New wheels are expensive, so if you don't want to break the bank, try to salvage one from an old wreck of a bike instead. Before you start, give the wheel a good wash-down – miles of cycling on the open road leaves a muddy trail, which you don't want in your home. If you like, you can also deflate the inner tube and take off the tyre.

There's a good chance that the spokes could be rusty; you could leave them like that for a rustic look, but if you want to add shine go to work with an abrasive scourer or tinfoil dipped in vinegar (be sure to wear gloves). For a more vibrant look, you could spray-paint the spokes and the metal rims. (Not necessarily a good idea if you're planning on reusing the wheel as an actual bike wheel at some point…)

Using wooden clothespins or bright bulldog clips, attach your pictures to the spokes in any haphazard arrangement that takes your fancy. Or you could take your cue from the circular nature of the frame and showcase your pictures in a spiral: begin at the centre of the wheel and spiral your pictures out like the inside of a shell.

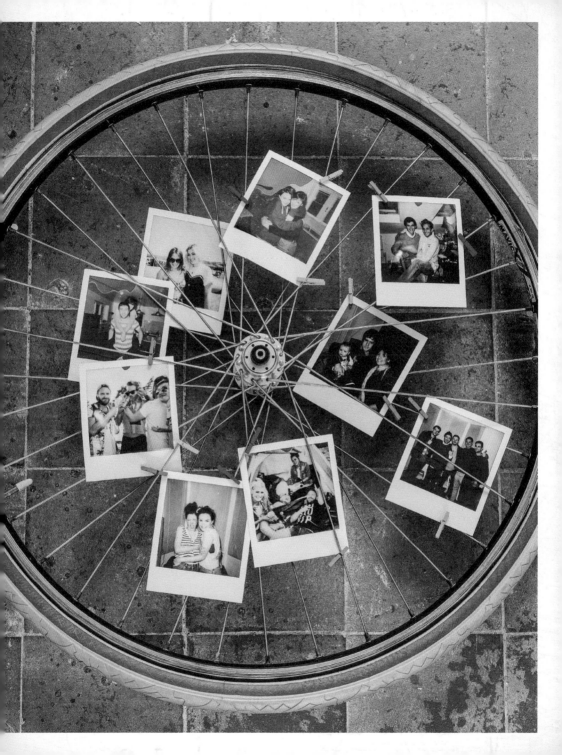

Face the music

All kinds of items can be turned into quirky frames to show off your favourite *Polaroid* photos – after all, every picture you take is a unique one-off, so celebrate their singularity with some equally special upcycled frames.

One approach will help you find a use for any old CD cases that you have knocking around. Take out the original cover, and pop your chosen *Polaroid* picture in instead. You could prop them on a shelf or mantelpiece or scatter them on a table, or go for a record shop vibe and stack them in a little box so that you can flip through them.

And don't discard the pack frames that come with your *Polaroid* instant films, as they can be made over as a frame for your pictures. Check inside the empty cartridge for the spring-loaded sheet – it will be either metal or plastic. Hold the sheet down, and post your photograph into the small slot on the bottom of the cartridge. If your picture is looking a little wobbly in its film frame, a bit of double-sided tape will keep it snug. Let it stand freestyle on a bookshelf or a desk, though you could pin it to the wall too.

Other ideas to try:

✤ Use some pliers to bend a fork into a home-made picture frame – the fork's prongs are perfect for holding photos.

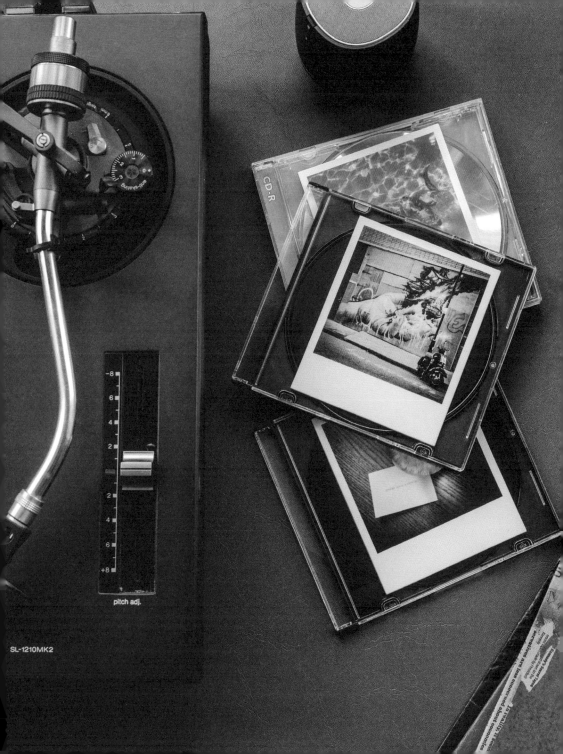

Tags with a twist

Everyone loves getting presents, but it can be nice to add an extra thoughtful touch that makes a present that bit more special. Instant photographs can make for perfect personalized gift tags, showing your favourite people that you care just that little bit more.

You could take a picture that means something to both you and the person you're giving a gift to – a picture from a great day that you spent together, or something more personal and symbolic. Another option is to take a picture of something that gives the recipient a hint about what's inside the wrapping paper – so attach a photo of a cup of coffee to the new coffee machine you're giving. You can even strike a nice pose and take a selfie to make extra sure that they know who the present is from!

If your *Polaroid* picture has a thick border, you can simply scribble a message there, then punch a hole in the top, thread some twine or ribbon through and tie it to your present. But if you're using film without a thick border, or if you don't want to punch a hole in your photograph, you can stick your picture to some cardboard and punch a hole through that instead. Pen a note on the back, thread some twine through the hole and you have a wonderfully personal touch to add to your gift.

Shelved

There's no need to hammer hundreds of holes into your walls to hang your proliferation of *Polaroid* photos in frames; a simple shelf can be a brilliant way of displaying treasured photos and brightening up a space.

Once you've selected a shelf (don't forget a bookcase or mantelpiece will work just as well), you can start to curate your display. You could go for photos only, framed or unframed, but take some time to think about where you place the pictures. If you crowd too many together, it can look overwhelming; leave a bit of breathing space between each picture so you can appreciate your handiwork.

You could also add books, records, plants and souvenirs to the picture parade. Again, spare a little thought to the arrangement of objects; are you going for junkshop chic or art gallery cool? You could pick out a colour in the photograph and surround the picture with objects that complement your chosen shade – a pale-green plate next to an image of a clear blue sky, for instance, with a vase of red and yellow tulips to add a pop of colour. Or you could theme your presentation: next to a picture of your favourite person you could add souvenirs that remind you of them – a flyer for a band that you've seen together or a copy of a book that you both love.

Other ideas to try:

❊ You can re-theme your shelf at certain times of the year. At Christmas, take some wintery photographs and decorate with Christmas baubles and fake snow.

❊ Halloween is a great excuse to use any of your more abstract snaps to eerie effect.

❊ If you're feeling really adventurous, you could use the shelf to create a scene from your own imaginary movie. Use your *Polaroid* pictures as a backdrop and then add in objects: toy cars, monsters, dolls'-house furniture … anything you can think of.

Cheers

You can easily transform your *Polaroid* pictures into drink coasters – it's a great idea for livening up a drinks table at a party or gathering.

There are two ways of doing this – first up, a quick, easy method that is perfect for parties. All you need to do here is find a thin sheet of transparent plastic (you should be able to buy this from an arts and craft store). Cut the plastic to fit your photograph, and sandwich the picture between two sheets of plastic – secure them in place by placing some tape around the edges. Scatter them about on tables.

The second method is more difficult but produces a higher-quality, more permanent finish. To do this, you'll need some supplies: a scanner and printer, scissors, some cheap tiles that fit the size of your photographs, white glue, a foam brush, and a can of waterproof acrylic spray.

Scan your photographs, then print them out to fit the size of your tiles, and cut each one out. Apply a thin layer of glue to the top of one tile with the foam brush, then carefully place your printed photograph on to the tile. Leave it for at least 20 minutes to dry. Repeat with all the tiles and images.

When they're dry, brush another thin layer of the glue over the image on the tiles. For the neatest look, make sure that all the brush strokes go in the same direction. At this point the glue will look white and smeary. Don't worry; leave it to dry for 20 minutes and it will become transparent. Do this a few more times to build up a few layers of glue.

Head to a well-ventilated area, or outdoors, with your waterproof acrylic spray. Following the instructions on the can, spray the top of the picture tile with the acrylic. Leave it to dry for as long as it recommends.

Once dry, apply another spray of acrylic and leave for another bout of drying and you're good to go. (If you want to protect your tabletops, then you can glue some felt to the bottom of the tiles.)

Toast your achievement with a drink of your choice! (The coasters aren't dishwasher proof; the best cleaning method is a wipe with a damp cloth.)

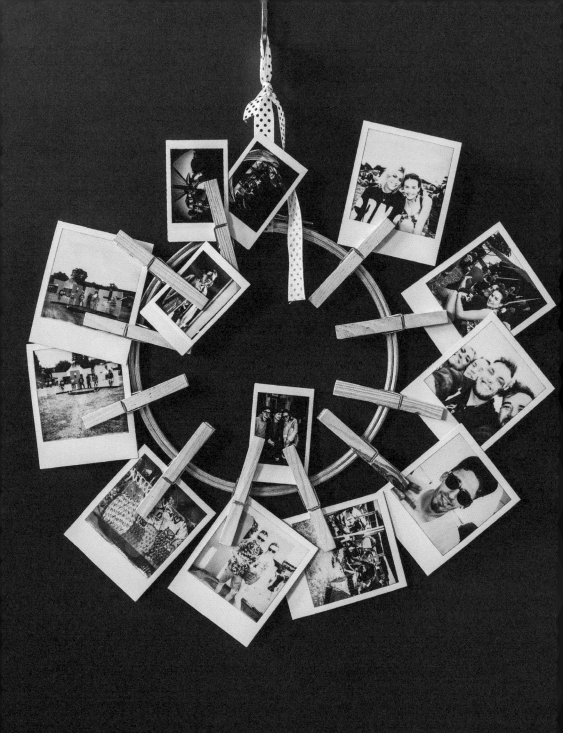

Hoop dreams

Old-fashioned embroidery hoops may seem to have very little connection to the world of *Polaroid* photos, but they can be made into a stunning centrepiece: a photo wreath.

Head to a craft store and pick up some embroidery hoops (whatever size best suits your space), a tube of superglue or a hot glue gun and some mini clothespins. Read the instructions before using the superglue or glue gun, and take care to protect yourself and any surfaces.

To make the wreath, lay the embroidery hoop on a flat surface. Use the glue to carefully stick the mini clothes pegs to the flat surface of the hoop, making sure that you don't glue the hinges of the pegs (or your hands!) so they can't open. The pegs should be flat, with the pinching end facing outwards; make sure that you space them out fairly evenly around the edge of the frame – you'll need to leave enough room to attach a *Polaroid* picture to each peg.

Wait until the glue has dried, then simply attach a selection of your photos to the pegs. Thread some ribbon through the hoop and tie the ends together to make a loop, then use the ribbon to hang the wreath wherever you like.

Other ideas to try:

❊ This is a great project for families or groups. Make a wreath for each person in the group, then let them decorate it with their own instant photos.

❊ Change the picture selection to suit the season – wreaths are perfect for Christmas celebrations.

Booked

A 'fanzine' is a DIY book or magazine that you make yourself. A rough-and-ready feel is part of its charm and it's a great way to show off your photographs. It can be about pretty much anything you can think of – bands, poetry, nature – or you can even create your very own comic strip, with your *Polaroid* pictures telling the story on every page. It all depends on your own interests, and what subject best suits your photos.

To get started, you'll need a pile of paper or cardboard and a stapler. Fold the sheets of paper in half, making sure that the folds are neat and crisp. Unfold the paper and place the pages one on top of the other, then staple them together along the fold to create a small booklet. (If you prefer a more sophisticated finish, then you can make a few stitches through the folds using a needle and some thick thread.)

Once you've made the booklet, you can start adding your *Polaroid* pictures in any way you like. Unlike commercial books, the beauty of your fanzine is in its unique, lo-fi feel, with slapdash lettering that looks like it was typed on a vintage typewriter, or with words cut out from magazines or newspapers. You can keep it nice and simple, sticking a picture on every page, with cut-out letters as captions. Use rubber stamps or stickers for extra interest, or stick in some postcards or other souvenirs to enhance the page. Or you can embrace a more elaborate scenario, incorporating your snaps into an illustrated story.

Other ideas to try:

�֎ To give your fanzine a more professional look, you can scan your *Polaroid* photos on to a computer and use design software to create your masterpiece. It takes away the DIY fun of the more hands-on approach, but it allows you to play around with your design before committing to it.

Shape-shifting

Grids are always good when thinking of a wall montage of your *Polaroid* pictures (see page 102), but instead of squares and rectangles you could think outside the box and throw some shapes.

First, think of a shape that means something to you. A smiley face perhaps? Or a heart shape? You could build a festive Christmas tree, a skyscraper skyline or the Eiffel Tower. You can even spell out words with your *Polaroid* photos – the name of a friend or loved one, for example, or a special message to someone using your favourite photographs of the two of you together. Whatever your imagination can come up with!

Once you have your idea, sketch it out before doing anything; old school maths books are great if you're doing it on paper, because you can use the squares to plan out your design. If you don't have any to hand, then a computer can be a useful substitute. Look at how many photos you have available, and try some combinations to see how best to create your preferred shape.

When you're happy with your shape, take to the floor. Lay out your shape to check that it looks exactly as you want it to, and play around with which photos go where – you'll find that some shapes naturally draw the eye to particular photographs (the peak of a skyscraper, for example), so make sure that you put your very best pictures in those spots.

Take a photo of the montage for easy reference, and then transfer your design to the wall. A ruler and some masking tape can be used to create guidelines to keep things looking neat.

Other ideas to try:

�֍ Add strings of fairy lights to draw further attention to your display.

�֍ Why stick to one wall? Have your montage spread over multiple parts of a room.

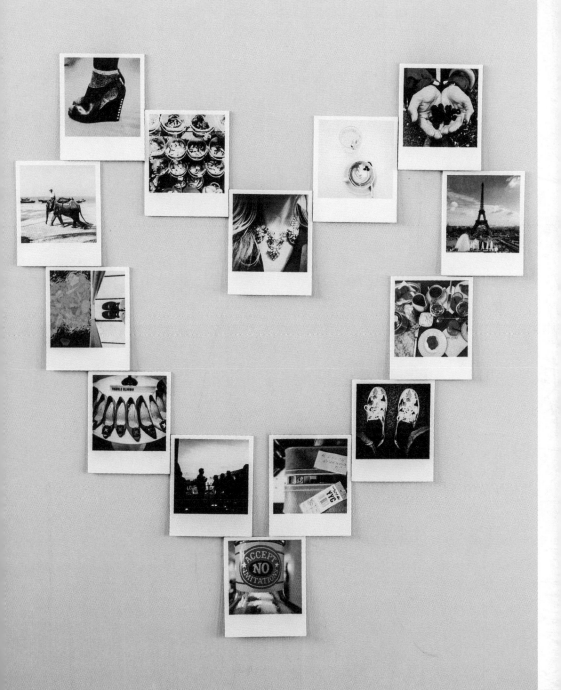

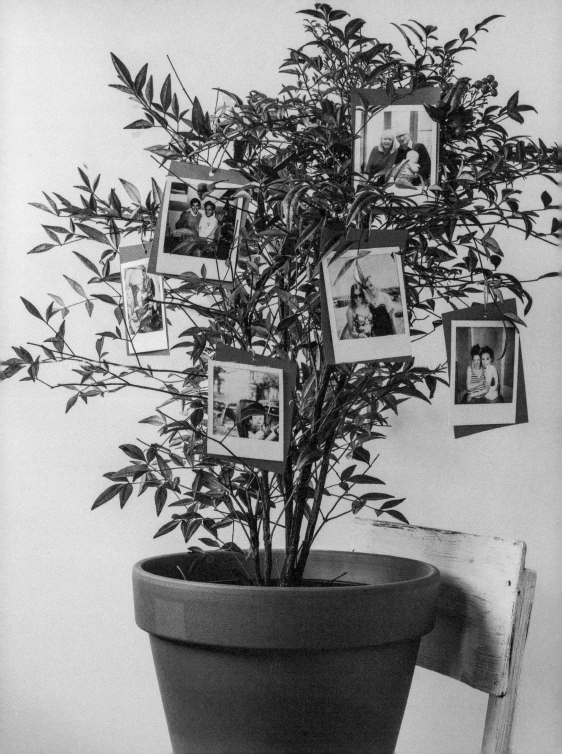

A family tree

A family tree is a lovely way of presenting *Polaroid* pictures of your nearest and dearest. You could make a wall chart, with lots of lines and photos connecting up your relatives and ancestors, or you could take the idea a little more literally; think Christmas tree, but with your instant photos as the decorations.

A bare autumn branch, with lots of little twiggy offshoots, will work brilliantly as a wall hanging, or you can use a houseplant for a more permanent fixture.

Once you've chosen a plant with twigs or branches strong enough to take a little weight, you'll need to select your *Polaroid* photos and turn them into hanging decorations. Gather together some coloured cardboard, a glue stick, a hole punch and some thread or ribbon.

The coloured cardboard is going to be the backdrop to your pictures, so cut it into shapes big enough to fit a *Polaroid* photo. Stick your pictures to them, then use the hole punch to create a hole in the top (this is to avoid you having to punch holes through your photographs). Thread some twine or ribbon through the hole and tie the ends together to form a loop. All that's left now is to hang them from your plant.

If you don't have a houseplant strong enough to hold your decorations, you can create lightweight versions by leaving out the cardboard backing, and simply taping loops of ribbon directly to the back of your *Polaroid* pictures. The results aren't quite as neat, but they should do the trick!

Single focus

One or two photographs can be just as powerful as a vast display. For a simple but effective display you can simply slip a *Polaroid* photo into the corner of the frame of a mirror or picture. However, you can also make individual frames for your favourite pictures.

The simplest ways are sometimes the best: a shop-bought frame can be lovely, and a small clipboard is a no-hassle way to showcase your picture. Pop your picture under the clip, and either prop the board on a shelf or nail it to a wall.

If you like the idea of your *Polaroid* pictures being behind glass but want a different look from a straightforward frame, why not use old bottles or jars for a quaint retro look? You can raid the store cupboard for a modern model, but vintage bottles and jars come in interesting shapes and shades so it's worth scouring garage sales and vintage stores for something special. Make sure that you wash any jars or bottles thoroughly in warm soapy water and dry completely before use.

And you can head down the simple DIY route, too. Wire, pliers, wire cutters, a large pebble and a fat felt-tip pen can produce a simple photo holder. Wrap the wire a few times around the pebble, use the round pliers to get a good grip and make sure that it's nice and secure. Leave a strand of about 9cm/3.5in (you can adjust this to make a longer or shorter holder) and then cut the wire with wire cutters – you can use scissors to do this, but it will blunt them. Twirl the top end of the wire around the pen a few times, and then gently pull the pen free. You should be left with a coil of wire; pull this coil upright and then simply place your picture in between the wire spirals.

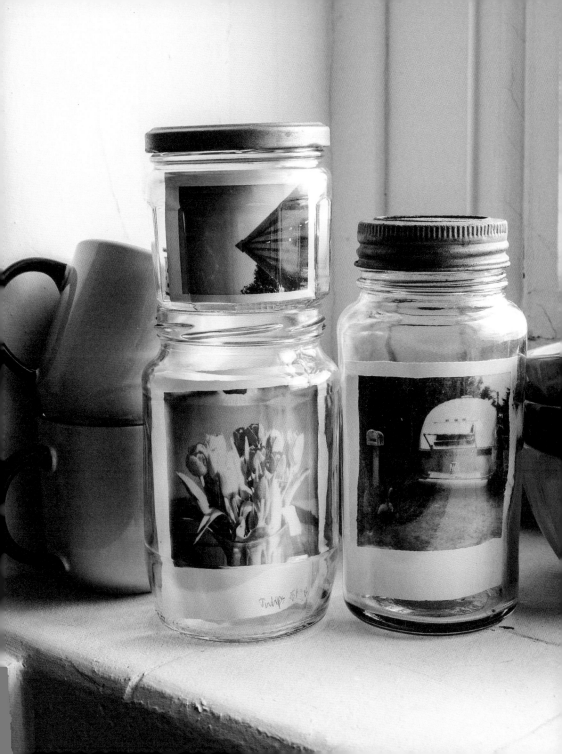

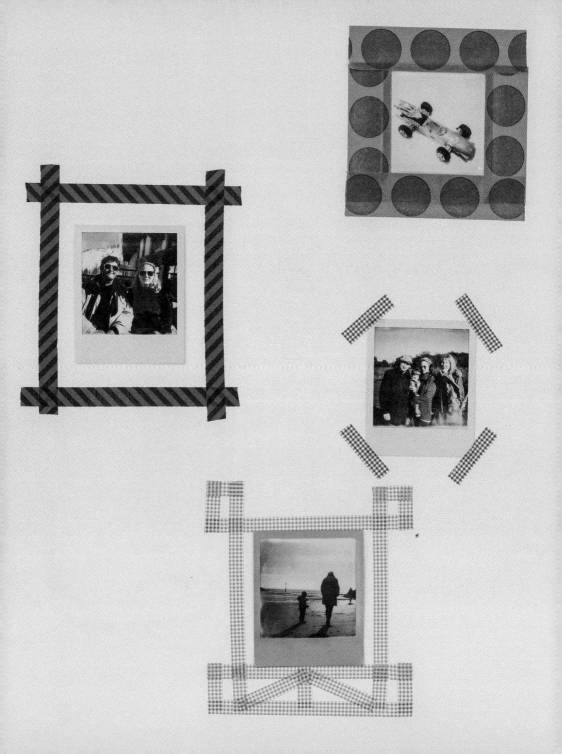

Sticky tricks

Patterned tape and *Polaroid* photos are a winning combination. You can buy tape in a huge range of different styles and patterns and use it to stick your pictures to the wall in a new and interesting way. (It's worth trying a small sample piece first, though, to check that whatever tape you buy doesn't damage your wall.)

You could keep it plain and simple and hold your picture in place with four pieces of bright tape, smoothed diagonally on each corner. Or you could go for something more decorative, and make some fantastic frames. Geometry is good – squares and rectangles, with neat edges and ruler-straight lines; to add a flourish, stick smaller squares to each of the corners. An emerald-shaped border will give your photographs a vintage feel, or you can be ambitious and take inspiration from art-deco shapes and lines. Alternatively, you could create a honeycomb, like the inside of a beehive, with linked hexagon shapes, placing your *Polaroid* pictures in the centre.

There's no need to stay with one style – mix and match the shapes and sizes of the frames, and go wild with colours and patterns, from the brash and bold to the pretty and pastel.

Other ideas to try: ❉ Add pattern and colour to a plain picture frame – a few strips of brightly patterned tape can transform a dull frame and bring your photos to life.

Beyond the frame

Everyone has a few photographs that they're especially proud of – an instant photo that effortlessly caught the mood of a moment, or one that you spent time thinking through and setting up, with particularly good results. The great news is that your images can be turned into practically anything, from mugs and bags to T-shirts and business cards, keeping the magic of your original *Polaroid* picture and taking it to a whole new canvas.

Though you can try a few of these projects yourself if you're feeling ambitious (fridge magnets can easily be made by attaching a strip of magnets to your photos, and you can buy iron-on transfers for making personalized T-shirts), there are a huge number of organizations that can create professional-quality products with your favourite *Polaroid* photographs.

The first thing you'll need to do is scan your image to a computer – this way you can transfer that unique instant-photo quality into a digital image. Choose how you'd like to crop your photograph; you may want to keep the famous white border around your image to make sure that it's especially recognizable as a *Polaroid* picture. And then simply search for a company that will print your images quickly and easily on to just about any product you want – from eye-catching business cards, to gifts with that added personal touch.

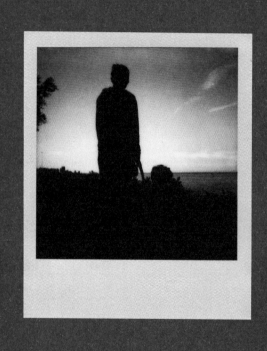

The *Polaroid* camera for you

Though the inspiration and that magic touch will need to come from you, the photographer, it is certainly worth taking the time to check that you are using the *Polaroid* instant camera that best suits you and your style. *Polaroid* has created a vast number of instant cameras over the course of its 75-year history, and the choice can be bewildering. Here, we run through some of the key models and their features – from the eye-catching classic models to the latest offerings that blend the worlds of instant and digital.

Polaroid 150 Land Camera
1957

The Polaroid 150 Land Camera is a very elegant machine which, though it would make a wonderful addition to any collection, is more suited as a reminder of the early days of instant photography than as a modern-day camera. This is mainly because it used a type of instant film which is no longer available – roll film.

Roll film is actually comprised of two separate rolls of film, a positive and a negative, which are placed into two separate compartments in the camera. To take a picture you set the shutter, focus the camera and follow the strict instructions in the manual to not 'snap' the picture (snapping the shutter jars the camera and spoils the picture), but to hold the camera firmly against your cheekbone and 'S-Q-U-E-E-Z-E the shutter release S-L-O-W-L-Y', as the original manual says.

Once the picture is taken you pull a paper tab out of the camera, which sets the development process in motion. That unwanted piece of paper is torn away using the cutting bar, whilst the picture forms inside the camera, which takes about a minute. But your involvement doesn't stop there. You have to flatten the image by 'drawing it over a table edge' and then applying six to eight strokes of the print coater to the entire surface of the print, including the edges and corners.

Though the lack of modern film means that it's probably one for the enthusiast, the Polaroid 150 serves as a fascinating look at how quickly and innovatively *Polaroid* cameras changed over the years.

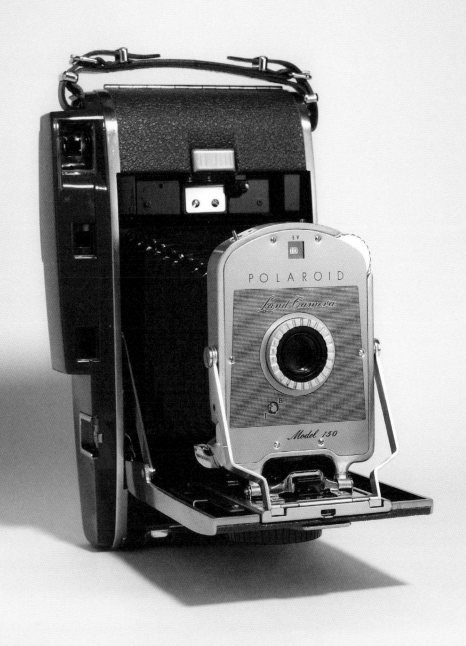

Polaroid 320 Land Camera 1969

The Polaroid 320 is a pack film camera – which gives you eight pictures per film, using the 'sandwich' method; for each picture there is a piece of negative film, a sheet of print paper and a thin foil container (the pod) that contains the jelly-like chemicals needed to develop the film. After snapping the picture you pull a piece of paper out of the camera, which drags the film, the print paper and the pod through the rollers. The rollers squash the pod, spreading the chemicals between the negative and the print paper – 'the sandwich'. Once you allow a little developing time, you simply separate your 'sandwich' and there is your picture.

You can buy newly manufactured film that fits the Polaroid 320 Land Camera today, but the difficulty lies with the batteries that power the camera, which are no longer available. It is possible to modify more modern batteries to fit the purpose, but it requires the help of a specialist who understands the machinery and is able to take the necessary precautions.

The Polaroid 320 is particularly remarkable for being fitted with an 'electric eye', which measures the brightness of the subject that you're photographing and times the closure of the camera shutter so that it gives the correct exposure. The manual recommends standing 1.5m/5ft away from your subject to get the perfect picture, and comes with the warning 'don't shoot flash pictures in explosive atmospheres'. For outdoor pictures it is happiest taking pictures of people on bright, hazy days, in close-up, or of subjects that are bright with bold colour.

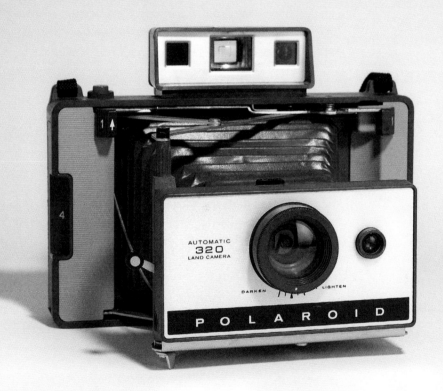

Polaroid Super Colorpack
1971

The Polaroid Super Colorpack was one of the affordable non-folding, rigid-body cameras that *Polaroid* introduced in the Seventies. They were very much aimed at the fun, fuss-free end of the market and were bought in their hundreds of thousands – so there's a very good chance of picking them up at flea markets, thrift stores and for not much money online (if possible, check that they've been tried and tested with film). It's best to avoid buying one that's chipped or cracked, as there's a danger that it will fall apart if it gets a little knock or has a fall.

They take pack film – that's the peel-apart variety (see page 17) – and two AA batteries, so check that the battery compartment isn't corroded. Before taking a photo, change the switch at the top of the camera depending on whether you're using black and white or colour film. They have an in-built mechanical development timer, so you'll know exactly when you should be carefully removing the backing from your freshly made print. There's a lighten/darken switch, which you can change depending on the light condition; in glaring sunshine, push the switch to the dark side.

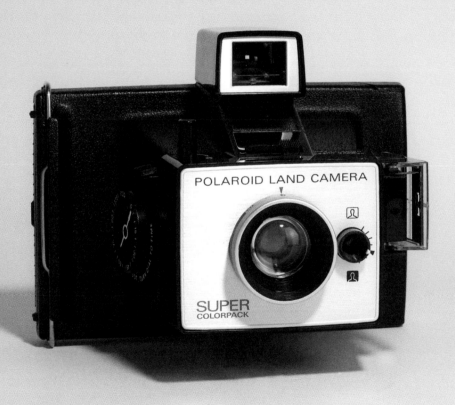

Polaroid SX-70
1972

The Polaroid SX-70 Original Model was the first instant SLR (single-lens reflex) folding camera from *Polaroid*, in production from 1972 until the early Eighties. At its launch, *Polaroid* founder Edwin Land snapped an unheard-of five photos in ten seconds, and it's still considered to be one of *Polaroid*'s finest achievements, beloved by camera enthusiasts and collectors alike.

Artists like Andy Warhol, Ansel Adams and Robert Mapplethorpe instantly spotted its appeal. It was the first camera to use integral film (which is widely available today), and because it folds shut it was easy to carry around, always on hand for a spontaneous photo shoot. It's a camera that loves the light – things can get a little blurry if shooting indoors, so shoot by a window with the light streaming in. A tripod also helps, or placing the camera on a table or pile of books works just as well.

The Polaroid SX-70 has an exposure dial that allows you to brighten your image – simply turn the dial to the right to lighten things, or to add some darkness turn to the left. You can manually focus the camera, and create a shallow depth of field, meaning that the object in the foreground will be beautifully in focus, while the background is delightfully blurry.

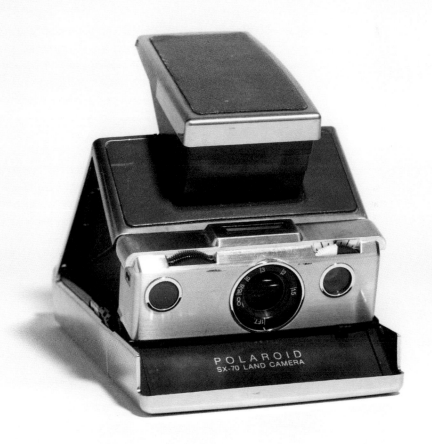

Polaroid OneStep Plus
1977

The rainbow decal on the Polaroid OneStep Plus has made this one of the most iconic cameras from *Polaroid* in terms of looks. It's also very simple to use, with its fixed focus plastic lens, and its use of integral film. In addition, it has a very handy film shade, which protects your picture from the light after it is ejected from the camera. (The shade is a little delicate so try not to tamper with it – it should automatically roll back once you remove your photo; if it doesn't, gently lift the front end and it should snap back into the camera.)

The Polaroid OneStep Plus has a light and dark dial to adjust the light level in your pictures, and can also be used with a flash bar. You can use a standard flash bar (there are modern varieties in production that will fit the camera), but you may still come across the retro Q Light, a device that supplies about 60 flashes, as long as you use brand new batteries. For the best result with a flash, stand 1.2–2.7m/4–9ft away from your subject, ideally in front of a light, colourful background.

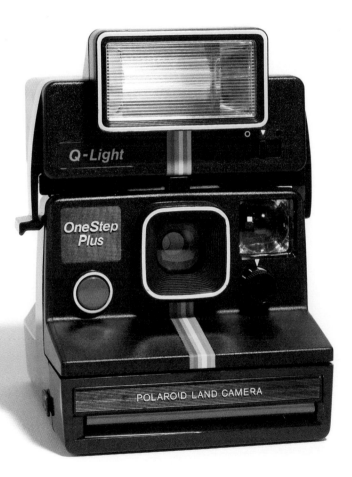

Polaroid 600 series
1981 onwards

The first Polaroid 600 was introduced in 1981, and was advertised with the slogan '*Polaroid* means fun'. They were hugely popular, and countless models were made up until 2008, with each new version boasting a fresh look or updated features. The roll call of Polaroid 600 models includes the Business Edition, the Double Exposure and the Night Camera to name a few, as well as a wide range of fun tie-in editions with all kinds of partners – from Barbie and the Spice Girls, to football teams, fizzy drink manufacturers and many more.

The Polaroid OneStep 600 was the first camera in the range and is the most basic model; it has a built-in electronic flash, which flips up for picture taking and folds down for carrying ease. Later models, like the Polaroid Autofocus 660 and the Polaroid Sun 660, came with a very useful auto-focusing system, helping you to bring your photographs into sharp focus. You can tell if your Polaroid 600 camera has this feature if it has a gold disc with a mesh cover, just next to the lens.

The Polaroid 600 cameras also have an in-built computer, which works with the flash to measure the light and work out just the right amount of flash needed to get the best pictures. The Autofocus models have a selection of lenses, and it's this computer that chooses which is the right one, and rotates it automatically into place so that your picture will be in sharp focus. The series also features a high-energy battery built into every film pack, which powers both the camera and the electronic flash, meaning you need never purchase other batteries.

Throughout the Eighties, the Polaroid 600 series was seen very much as a social camera – the in-built flash and focus mean that it's great for parties and it has a 'Talking Camera' feature, allowing you to record speech and short bursts of music. In fact, this reputation as a party camera occasionally

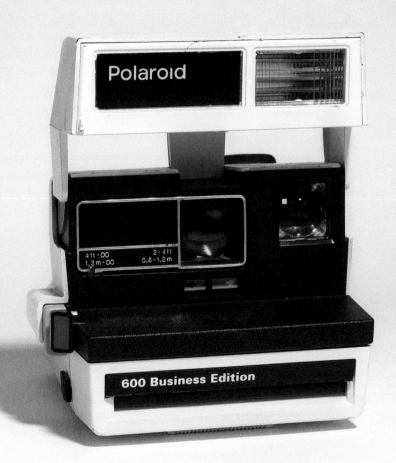

led to people taking it a little too far outside its comfort zone; some models were fitted with stickers reminding people that the cameras weren't waterproof. On dry land, the cameras do work very well in the great outdoors.

As time went by, more and more Polaroid 600 models appeared on the market, all with their own unique features and styling. The Impulse range has a very different look: sharp edges, diagonal lines, and a range of vivid colours – from sunshine yellow to magenta. Unlike most *Polaroid* cameras, the Impulse models don't fold down, but come with a handy self-timer, so you can be in the picture too – ideal for selfies (see page 59).

Later versions of the Polaroid 600 adopted a more sleek, chic, aerodynamic look and have close-up adaptors and LCD frame counters, self-timers and a flash that can be switched on and off, giving you more control over the look of your photos. There are even SLR editions; the Polaroid SLR 680 and Polaroid SLR 690, which are considered more professional cameras. They come with a removable back, interchangeable lenses and fully manual control, and work well in low light and indoors. But, like the Polaroid SX-70, their favourite conditions are bright sunlight, as well as little shade and some cloud cover.

So with all of the models, special editions and different features, there really is a Polaroid 600 for everyone. Newly produced film is widely available.

Polaroid Spectra Onyx 1987

The Polaroid Spectra Onyx is one of the most interesting *Polaroid* cameras around. The Spectra range, introduced in the early 1980s and made until the early 2000s, was sleek and contemporary, but the Polaroid Spectra Onyx stands out on its own – it has a transparent top, meaning that its elegant internal components are there to see. The camera uses Spectra film, which is available to buy – the prints are larger in size, and rectangular rather than square.

All Polaroid Spectra models have auto-focus, a self-timer and in-built flash, but you can override these functions if you wish. When you press the shutter button halfway a number and a symbol will appear in the viewfinder – the number tells you how far away you are from your subject. If a green circle appears, that's the camera's computer telling you that you can go ahead and click, but if a yellow triangle appears then that's the Spectra suggesting that you call a halt and adjust your settings. The camera works well indoors and outside with the flash, but it comes into its own in bright sunshine, or with a little cloud cover, with the flash turned off. It makes for a perfect sunny holiday camera, producing soft, glowing images.

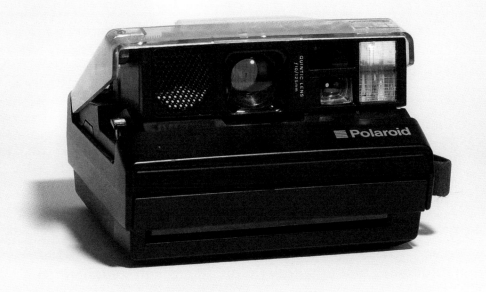

Polaroid OneStep Express 1997

The Polaroid OneStep Express is a later model from the hugely popular Polaroid 600 range of cameras (see pages 140–143). It has a cute, rounded shape, made from durable plastic, and when it's closed it looks a lot like a bread bin – which it was affectionately nicknamed by *Polaroid* fans.

The camera has lots of familiar features, including the lighten and darken exposure dial, and a close-up lens – to use it you simply slide the close-up lens to the right. (It works best when your subject is about 60cm/2ft from the camera.) It's a self-focusing camera with an automatic flash, but it is possible to override the flash if you prefer – look on the side of the camera, and you'll find the shutter button. Immediately underneath that is a little black button, which cancels the flash. It's a great feature if you're shooting metallic or shiny surfaces, or shooting a subject through glass. You can also shut the front side to protect the lens when you're not using it.

The Polaroid OneStep Express takes integral film (modern versions are available), and to load the film you have to pull the impressively large flash bar upright, and then click open the film door. All the usual rules apply when you're waiting for your picture to appear; remember that your print is fairly fragile, so don't shake it or bend it and if the temperature is below 13°C (55°F) pop it in a warm location – like your pocket – to get the best results.

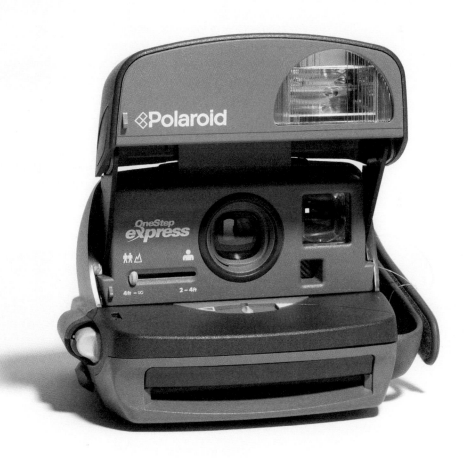

Polaroid i-Zone
1999

The Polaroid i-Zone is a fun, easy-to-use camera, initially aimed at teenagers. It comes in a range of vibrant colours, has soft grip edges and is incredibly compact, meaning that it's easy to hold and very simple to use. It was designed with younger people in mind, and so makes things simple by featuring clear instructions printed as illustrations on the bottom of the camera. Its range is 60cm–1.8m/2–6ft, and once you snap a picture the camera turns itself off automatically in order to save on battery life. You can adjust for different light conditions with a nice chunky dial, allowing you to select 'outdoor sunny', 'outdoor cloudy' or 'indoors' settings.

The film, which is no longer widely produced, came in packs with 12 exposures, and created a compact print with a decorative border in a range of different designs. Some feature sticker adhesive on the back, meaning that you can peel your photos off and stick them to all sorts of surfaces. Beneath the fun, youthful exterior, the film pack is actually a compact, stylized version of the same integral film that features in many cameras created by *Polaroid*, emerging from the right-hand side of the camera and developing in the same way as other integral film stocks.

Despite its simple, approachable style, film for the Polaroid i-Zone camera is now fairly scarce, and so it's not the best choice of camera if you're just starting out on your instant photography adventures.

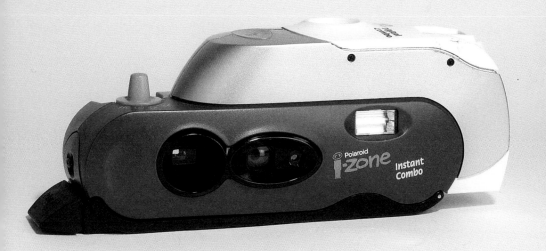

Polaroid Pic-300
2010

Stylish and fun, the Polaroid Pic-300 is curvy, robust and surprisingly light. It's very simple to use, with just four picture modes (indoor/dark, cloudy/shady, fine and clear) and a simple system for turning the camera on and off: simply pull out the lens to turn the camera on, and wait for the indicator light to turn green. (To turn it off, you just need to push the lens back in.) Much like the classic Polaroid 600 series, the Polaroid Pic-300 is a camera that loves an after-hours party. The indoor/dark setting is perfect for evening events, and the automatic flash makes for well-lit instant photos.

The Polaroid Pic-300 produces small, rectangular instant photos, which pop out of the top of the camera and take around 90 seconds to develop. Loading the widely available film is a simple process, in which you pop the back of the camera open, slot in the film, hit the shutter button to eject the film cartridge's protective sheet and then begin shooting your photographs.

One of the most appealing things about the Polaroid Pic-300 is its colour – the film develops into incredibly vibrant hues and tones, allowing you to experiment with all sorts of subjects and shooting conditions.

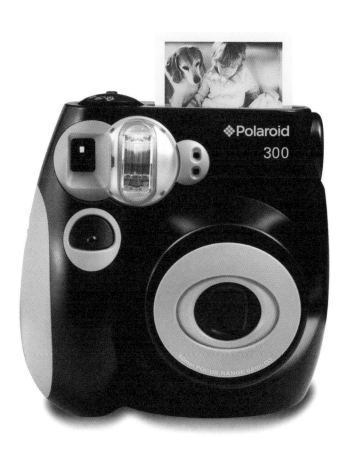

Polaroid Z2300
2012

The Polaroid Z2300 Instant Digital Camera is the best-selling instant digital camera from Polaroid and is a modern twist on the vintage classics. It uses ZINK Zero Ink printing technology and pops out 50x75mm/2x3in sticky-backed photos in under 60 seconds.

A major benefit of this model is that you can choose the photos you want to print out and save the rest, so you get the best of both worlds – instant photos or a digital file, and a chance to delete any pesky mistakes. You can also add the Polaroid Classic Border Frame, among others, to your photos and edit the colour, moving from cool black and white to vibrant colour.

It can be used just as a regular point-and-shoot camera, as it has a flash, a 75mm/3in LCD screen on the back, an SD card slot, and a mini-USB port for uploading shots to a computer. You can leave it in auto mode and let the camera do the work for you, but you can also manually change shutter speeds, and adjust the white balance. And you can switch between landscape and macro settings, allowing you either to go for epic-feeling wider shots, or to go in close and hone in on small details.

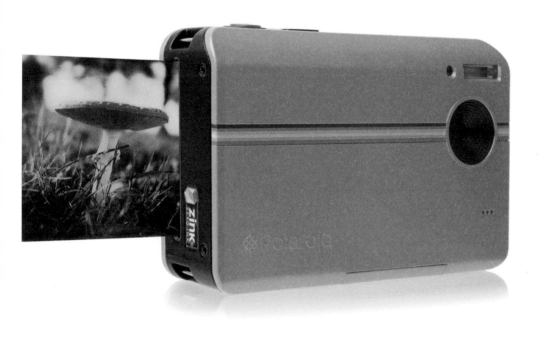

Polaroid Socialmatic
2015

The Polaroid Socialmatic is a camera, tablet and printer in one, which as well as taking photographs allows you to browse the internet and check your emails at the same time. It has two cameras, a front-facing 14 megapixel lens and a smaller 2 megapixel 'selfie lens', which lets you snap pictures of yourself and your friends, save them to the internal memory or upload them straight to social media, using Wi-Fi/Bluetooth.

Or you can keep it classic and print off 50x75mm/2x3in smudge-proof, tear-resistant images in seconds. As with the Polaroid i-Zone and Polaroid Z2300, the prints also peel apart and have a sticky reverse side, so you can use them as stickers too. And you can play around with your images before you print or send them using the Polaroid Socialmatic's in-built editing software – it's easy to crop, adjust the exposure, add special effects and text and banish the dreaded 'red eye'. You can take a photo using the touch screen, or press the button on the top of the camera – and the LED flash is great for lighting up faces and objects in close-up. There's also a timer, so you can get in on the action, and it's perfect for shooting video as well as photographs.

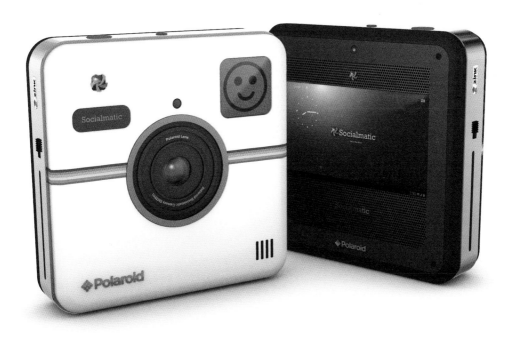

Index

Credits

The publishers would like to thank the following photographers for supplying images used in this book, all of which are the photographers' copyright.

Anne Bowerman 8, 12 r, 15 ar & br, 21 l & r, 22 al, 23, 33 l, 34 a & b, 35 l, 41 l, 79 al, 84 a, 85al, 90 bl, 91al & ar
Andrew Cottington 67 a
Joep Gottemaker 13 l, 18 al, 19 l, 22 ar, 39 r, 76, 78 a, 82 a, 83 al, 86-87, 88 a, 89 al, 90a, 92a, 153
Toby Hancock 27 al, bl & br, 37 l, 51 all, 79 ar
Andy Jenkins 7 r, 13 r, 84 br, 88 br, 93 al, ar & br, 128
Sarah Kirkham 10, 17 b, 22 b, 24 r, 25, 29, 30 l, 33 r, 42, 79 br, 81 br, 83 bl & br, 89 ar, bl & br, 91 bl & br, 94, 151
Daniel Meade 2, 11, 17 a, 18 ar, 30 r, 80 a, 83 ar, 84 bl, 85 ar, 90br, 160
Florian Stephens 7 l
Laura Alice Watt 32 l & r, 35 r, 80 br, 81 bl, 88 bl
Juli Werner 4, 15 al, 16 l, 28 r, 37 r, 38 r, 80 bl, 81 al & ar
Meredith Wilson 16 r, 18 br, 19 r, 20 l & r, 27 ar, 28 l, 38 l, 39 l, 41 r, 79 bl, 82 bl & br, 85 bl, 92 bl & br, 93 bl
Marcelo Yanez 12 l, 15 bl, 18 bl, 24 l, 78 bl & br, 85 br

Project photographs were supplied by Ellen Bashford, Andrew Cottington, Grace Duignan-Pearson, Ellen Edmondson, Lauren Edmondson, Haarala Hamilton, Abigail Read, and Florian Stephens.

Project photography by **Haarala Hamilton** © Octopus Publishing Group Ltd.

The Legoland *Polaroid* camera on page 143 appears with the permission of **The LEGO Group**. LEGO, the LEGO logo, the Brick and Knob configurations, the Minifigure and LEGOLAND are trademarks of the LEGO Group. © 2015 The LEGO Group.

Photography of the camera models featured on pages 131 to 155 © PLR IP Holdings, LLC.

An Hachette UK Company
www.hachette.co.uk

First published in Great Britain in 2015 by Mitchell Beazley,
a division of Octopus Publishing Group Ltd
Carmelite House
50 Victoria Embankment
London EC4Y 0DZ
www.octopusbooks.co.uk
www.octopusbooksusa.com

Distributed in the US by
Hachette Book Group
1290 Avenue of the Americas
4th and 5th Floors
New York, NY 10020

Distributed in Canada by
Canadian Manda Group
664 Annette St.
Toronto, Ontario, Canada M6S 2C8

ISBN 978 1 78472 084 1

A CIP catalogue record for this book is available from the
British Library.

Text written by: Eithne Farry

Commissioning Editor: Joe Cottington
Editor: Pauline Bache
Copy Editor: Robert Anderson
Designer: Jaz Bahra
Project photography: Haarala Hamilton
Picture Research Manager: Giulia Hetherington
Assistant Production Manager: Caroline Alberti

Printed and bound in China

10 9 8 7 6 5 4 3 2 1